PHILLIP LEVINE

MYTH, MEMORY & IMAGE
SCULPTURE AND DRAWINGS

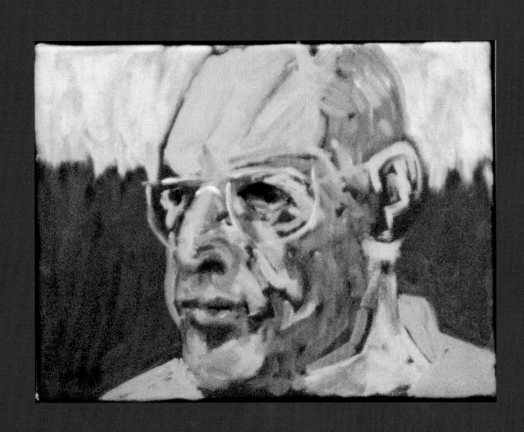

PHILLIP LEVINE

MYTH, MEMORY & IMAGE

SCULPTURE AND DRAWINGS

WITH CONTRIBUTIONS BY

NORMAN LUNDIN & TOM JAY

MUSEUM OF NORTHWEST ART, LA CONNER

DISTRIBUTED BY UNIVERSITY OF WASHINGTON PRESS
SEATTLE AND LONDON

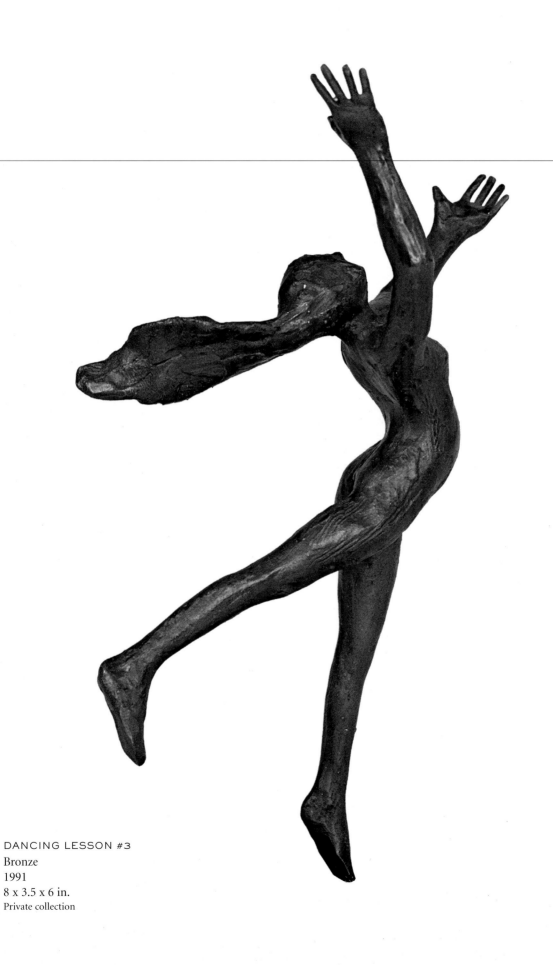

DANCING LESSON #3
Bronze
1991
8 x 3.5 x 6 in.
Private collection

CONTENTS

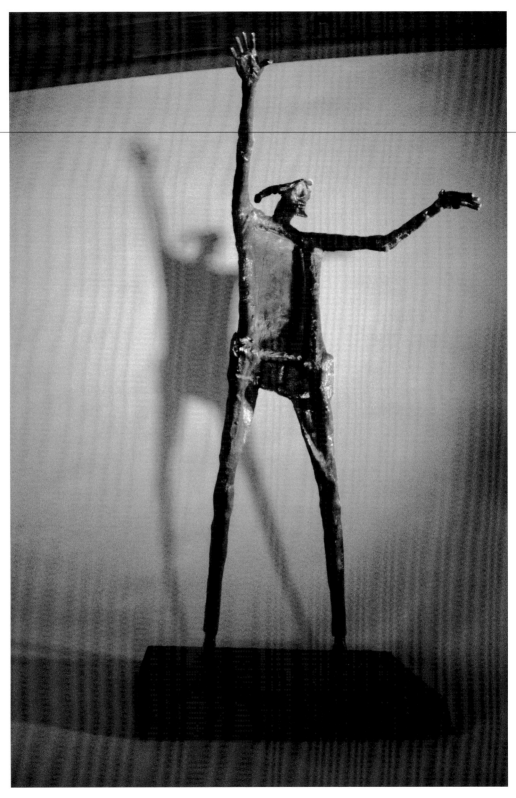

MAGICIAN
1991
Bronze
27 x 13 in.
Collection of Helene and Ziel Feldman

COMMENTARY

TOM JAY

Phil Levine is a master of the human figure. His portraits, drawings, and wide variety of life-sized public and private sculptures bear witness that his faithful discipline—studying and interpreting the human figure—has served the larger calling of his inspirations. The *radiant* spectrum of his *imaginations* would not be possible without his focused and tempered dedication to exploring ways the human form may bear myriad meanings. The angels of his inspiration have been wrestled into mortal form by his skilled hands and keen eye. In short, Phil's work, the *eros* of his sculptural endeavors, is about revelation, the formal invitation to shared meaning. Phil instinctively avoided the stampede into the subjective infantile "expressions" of postmodern relativism. He chose a subtler path: a secret, soft-touch iconoclast, his work wedges cracks in our habitual patterns of perception and offers forms that coax into being a whispered story, a distant flash of light in the cloud-dark dawn, a warning shadow in the summer day. Phil shuns the clever to serve a deeper calling.

Over the forty years I have known him, Phil has been a student of the figure: it is his medium as well as the subject of his meaning-making. He exaggerates and shape-shifts its attributes to confirm and convey his amazing range of messages. Keep this notion of figure as medium/subject in mind as you peruse the adventure of Phil's work documented in this book.

Phil's oeuvre is not about representation. It is not historical; it is subtly mythological. Entering the "room" these figures create, we experience a larger story that is not personal or confessional. These figures and their situations, their "pose," quicken our shared humanity, our common soulfulness, the paradoxes, dilemmas, and joys of living. The acrobats, jugglers, striders, leapers, and tipsy ladder people become *figures*, mythic vocabulary in our stories. Phil's works pose or hint at questions, but the questions are not reductive. These sculptures are not masks for literary riddles or witty puzzles; there are enigmatic, even dangerous and subtly unsettling questions being opened here. The work is familiar and mysterious at the same time: who are those long-striding women and where are they going? Who is the woman in the hat and what is she directing us to attend? Phil dares us to delve into the sculptural pose and divine the mystery constelled by his stark, serene presences, "figures" that embody both the beauty and the darker impulses that grace and haunt the human way.

The general reader needs to know one last element of Phil's creative process. In addition to his

dedicated exploration of the sculptural possibilities of the human form, Phil is also a curious and adventurous craftsman. He fired and glazed his own hand-built sculpture and cast in bronze nearly all the work (large and small) in this book. This is a crucial note: Phil's experience and intimacy with all aspects of the materials and craft of sculpture production, especially the years he operated his own casting facilities, encouraged him to explore creative possibilities using bronze's great tensile strength. Phil's practiced skill with metals allowed him to engineer many daring and startling pieces that sculptors unfamiliar with the "nature" of bronze would be too timid to attempt.

Phil's gift was to marry his deep curiosity about and knowledge of the human figure and the surprising strength of modern bronze alloys (silicon bronze) reinforced by stainless steel infrastructures to continue to push the envelope, to further *the quest to pose another question.* That wasn't all. He also experimented with the constructivist techniques, employing cardboard, cloth, wax, and other combustable materials to create one-of-a-kind bronzes that had the erie feel of doomsday chess pieces come to life.

Phil's skills, dedicated attention to his subject *mediums* and materials placed and worked in the service of a larger imagining confirm him, in my witness, as a real working artist, a midwife to wonder.

PREFACE

NORMAN LUNDIN

Phillip Levine's work first entered my awareness in 1968 when I saw a show of his drawings and small sculpture at the Cascade Gallery in the Seattle Center. It was the drawings that first caught my attention. I could see, right away, that he possessed a fine "eye," and that "eye" was also apparent in his sculpture. I met him not long after I saw this show, and we've been friends since. I should add, in the spirit of "full disclosure," that I own several of his works.

His work is almost exclusively the human figure. Of all the problems that have confronted Western artists, depicting the human figure is the central one. It's not the only problem, it's just the central one. A singular advantage of the human image is that there is no, absolutely no other subject matter that has the expressive potential that is contained in the human image. (Often one will see an artist, whose work is nonobjective, include a worried, fretful face in his/her work in an attempt to give the work an expressive punch that the nonobjective work does not otherwise possess.)

Of the human figure, it's the human gesture that the artist must get "right." You get the gesture wrong, and you'll sink the whole thing; it's a potential minefield of missteps. I include, when speaking of gesture, standing figures that do nothing but "stand." To do a standing figure and have us want to look at it repeatedly is an excep-

tionally difficult task for any artist. Giacometti did it, as you'll see in any of his figures from the nineteen-fifties and sixties. López-Garcia did it too; look at his *Man and Woman* (life-sized wood, 1968-94). Levine's *Woman Dancing* gets it right as well—the gesture is forceful, and it's this gesture that makes us continue to look. The problem is not getting a figure anatomically correct, or, if abstracting it, getting a formal excellence; the problem is getting it "right." "Well," you'll say (justifiably), "what do you mean by "right?"

The difficulty of explaining "right" is that it's not constant—what we mean by "right," in this context, changes as our values evolve. What was "right" and powerful decades ago may not be so today. When we look back and say that an artist was ahead of his/her times, we are saying that that artist reflects values we hold today. "Presentism," an attitude about things past dominated by immediate contemporary values, is always brought into play.

Certainly Rodin holds singular fascination today. Compare him to his contemporaries and he'll command our attention far more than any other sculptor of the middle nineteenth century to the early twentieth. He does this with formal invention of a very high order. It is, though, the subjective expressiveness that grabs us. This quality is what makes his work modern. The expressiveness

of his work transcends his era and is reflective of values we hold today. Many of his contemporaries were artists of absolutely stunning formal skills. We look at them, we may admire them, but we put them on a lower step than Rodin.

In both sculpture and drawing Levine gets the gesture right. After the human face the hands are the most expressive part of the human anatomy, and his hands are marvelous. It is an exquisitely fine line between a gesture that convinces us of the sincerity of the emotion expressed and one that is expressively melodramatic. Look at *Laocoön* (marble, Roman, 1st century BCE), compare it to the *Dying Gaul* (marble, Hellenistic Period, 250 BCE) and you will see what I'm getting at. *Laocoön* is a splendid classical work; it was and is hugely admired in Western culture. A century ago it was considered to be the apex of classical sculpture; now we give it a somewhat lesser standing. *Laocoön*, today, appears melodramatic. He and his sons are fine actors, they will return to perform in their play another day. For the *Dying Gaul*, though, this is it. For him, his last day—he won't be returning.

In his drawings Levine consistently gets the body and hand gesture right (see *Woman Dancing*, a larger than life-sized bronze in Olympia, Washington). His knowledge of the skeletal structure and muscles is considerable; it is implied in his drawings and sculpture even when those works are the quickest of sketches.

It's amazing how a single line expresses both muscle and bone (see the drawing *Arms Crossed*). These observational skills come from years of making three-dimensional wax and clay studies. Levine's hands have developed a kinetic memory

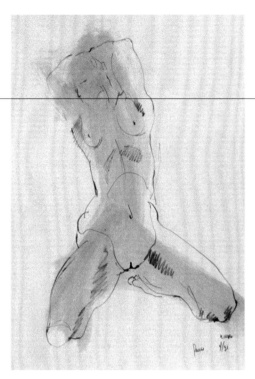

ARMS CROSSED
Graphite with wash
11 x 8.5 in.

of what they're making in three dimensions, and that three-dimensional knowledge is transferred to his two-dimensional works. He's been drawing from the model for decades; this practice definitely has a payoff in his ability to abbreviate the form and still have all the necessary information beautifully described. And, it *is* practice, much of his work is done without artistic intent; the result may be artistic, the intent though, often isn't.

His bronze life-sized *Dancer with Flat Hat* has the rightness of gesture that a dancer possesses, and works superbly in the round. It is the most photographed work at the University of Washington and rightly so—it connects to those who are not knowledgeable about contemporary art as well as those who are. It's a fine ability to have that kind of breadth. And breadth is what he has. I am impressed.

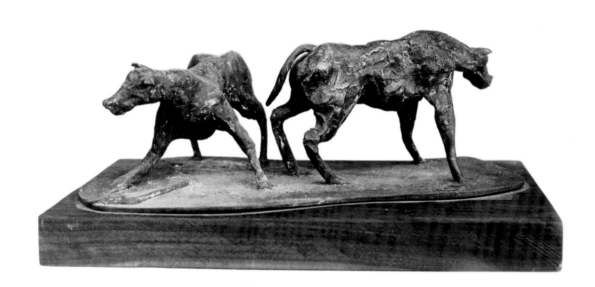

WILD BEASTS
1963
Bronze
4.5 x 6 x 4 in.
Collection of Mr. and Mrs. A. M. Arnold

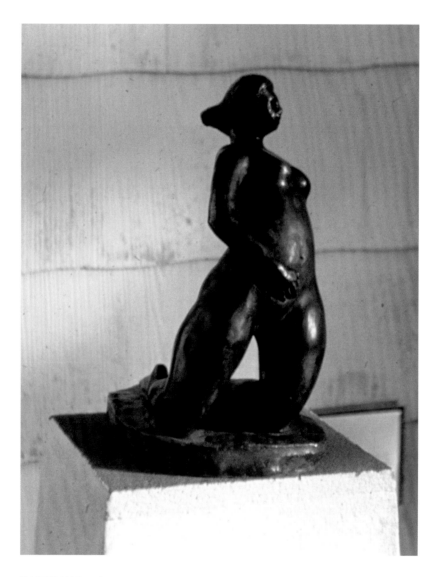

KNEELING WOMAN
1973
Bronze
10.5 x 6 x 5 in.
Private collection

INTRODUCTION

I have a twofold purpose in presenting this book. One is to show the history of my sculpture over a period of fifty years—not in a particular time sequence, but by the progression of themes that have run through it. The other is to acknowledge the influences, teachers, mentors, and experiences that may illuminate some of the sculptures.

The human figure is the basic element of my work. Over the years as I gained an understanding of the figure and the capabilities of bronze, my sculpture emerged representing certain themes. Often there has been an overlapping or compounding of themes in any one sculpture. In all these motifs—dancer/singer, acrobat/sport, literary, man/machine, social commentary, interrelationships, figure/structure, and structure alone with man implied—the human figure was my core concern and interest.

A few years ago, while preparing to give slide presentations of my work, I began sorting through over 650 images of the sculptures I had done during the five decades of my career. In getting together what I felt would be a representative overview, I realized that certain themes were consistently presented. Until then I had thought of myself as an intuitive sculptor. By claiming intuition as my source I kept the door open for inspiration and content. In visual art it is the body of work that shows its nature, not a single piece. As I looked at the body of my work I saw that its thematic sources lay not in intuition but in my experience, intelligence, education, society, and interests. All of these elements combined to make a wholeness that allowed me to do sculpture. In probing the source of my work I became aware of how myths (storytelling), memory, and image had influenced me.

SINGERS/DANCERS

The art school, which I attended for a short time in Denver, shared space with a dance school—the start of the influence of and my interest in dance, which lies at the heart of so many of my sculptures. Their fluidity of movement contrasted greatly with the static poses of a more classical time. In Seattle many dancers maintained and raised my level of interest and understanding of the dance. Among those were Eve Green and, later, Hannah Wiley, directors of the Dance Department at the University of Washington, as well as Llory Wilson, choreographer and dancer.

LITERARY

Raised in a milieu of "the book," I had been drawn to storytelling. Words are to the forms of writing as shapes are to the forms of sculpture. A picture or image is not always worth a thousand words but it can depict another level of appreciation.

Sculpture is three-dimensional storytelling. How does *Sitting Woman*, for example, tell her backstory? Sculpture leaves a great deal of room for the viewer to bring his/her story to add to understanding and enjoyment. The question of why we are here leads us to look to others who have asked the same questions. It is the asking that is rewarding.

SPORT/ACROBAT

Sports and movement were always a part of my activities. The many sports I played required me to use my entire body. My later studies of the body showed me how the movement of one part affected the movement of another. Understanding

WOMAN WITH SCARF
2001
Bronze
12 x 11 x 8 in.
Collection of the artist

and exploring this relationship were the keys to the rhythm of the gesture and action.

MAN/ANIMAL/MACHINE

The body has its functions and parts, as do machines and animals. To dissect, reassemble, and combine them enabled me to represent different relationships and views of our world.

SOCIAL COMMENTARY

My grandparents had fled military and religious oppression, which was a recognized factor in my upbringing. My background formed the basis of my value system. Being Jewish I viewed myself as an immigrant in society, with a need to participate in the social life of the community. (My antiwar sculptures, the *War Machines*, were initiated during the 1969/1970 era). My parents were part of the internal migrations of the Depression years and our home was filled with family and friends living together under one roof. It was an environment rich in conversation, argument, books, love of theatre, and music.

INTERRELATIONS

In a society where economic, social, and cultural changes are rapidly taking place, I have always been fascinated by how people reacted or behaved in their activities. I have had a broad milieu of family and friends from which to draw.

FIGURE/STRUCTURE

The sense of our environment and the spaces we lived in were paramount in my childhood. We had moved a great deal during my early years, which

developed my sense of the relation between myself and physical structures.

Never wanting to over-analyze why I had chosen these themes, I nevertheless needed to offer some explanation for why I'm presenting them in this book. I needed to look back at my roots and understand the directions I had gone. Now having done so, I wonder how my sculpture will be affected by this overt examination? What level of consciousness will be the operative one? I look forward to that effort, as always, with the open approach and curiosity about what and who I am as I walk into the studio.

I was born in Chicago, Illinois, in 1931, where we stayed until 1939, when my parents, Max and Belle, and my sister, Sandra, left for Dayton, Ohio; Green Bay, Wisconsin; then Denver, Colorado. Our moves were necessitated by the loss of my father's business during the Depression. Eventually we settled in Denver. I graduated from East Denver High, lettering in tennis, and enrolled in the University of Colorado, where I completed a BA in Art in January 1953. My university experience included memorable opportunities to make objects with my hands, which gave me a focus of pleasure and activity that touched everything else.

After a short art school experience in Denver, I went East. New York was the Mecca of my generation of artists who grew up in the Midwest. It was as a painter that I moved there in 1954. There I met and shared a studio with Roger Barnes, a painter who had studied at the Art Students League, and Robert Templeton, who later became a well-known portrait painter. I showed paintings at the Roko Gallery in 1956, and continued paint-

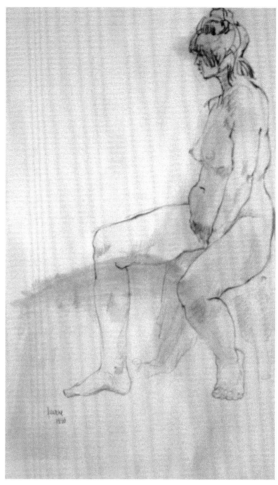

AT EASE
Graphite with wash
14 x 8.5 in.

ing until 1957, when I began to do sculpture. I enjoyed working with my hands. Even though tools were used in the sculpture process, I enjoyed the sensual, tactile sense that came from *feeling* the forms.

I met Rachael in 1956 while visiting family in Denver and we were married in New York in 1957. We lived on East 12th Street, where Rachael could walk to work at Beth Israel Hospital and I to my studio at 2nd Street and Avenue A. A year after my transition from painting to sculpture, I realized

that I needed more sculpture training. The birth of our first son, Joshua, also accelerated our desire to move from the Lower East Side.

Because it appeared that I could get an MFA in Sculpture in one year, I enrolled at the University of Oregon, where Jan Zach was the primary sculpture professor. Although his interest lay in non-objective art, which had little appeal for me, I passed the sculpture exam, enabling me to continue in the department. But because of my different aesthetic goals and the lack of work opportunities at that time in Eugene, I remained there for one quarter only. Chuck Forrester, a fellow graduate candidate, told me about Professor Everett DuPen at the University of Washington, and DuPen's interest in figurative sculpture. So in January 1959 we moved to Seattle and I entered the university graduate program.

My desire for further education was renewed when I began my graduate studies in Seattle, where I was a teaching assistant during most of my time at the UW (1959–1961), and also taught drawing and a design class. My graduate thesis encompassed polychrome stoneware clay sculptures. I continued to work with the idea of integrating color with the medium. After receiving my MFA in Sculpture in 1961, I became a part-time acting instructor and taught classes in drawing for one year. I began working in bronze as I fulfilled my graduate teaching commitment.

My primary income at this time came from doing commercial art paste-ups for the Harry Bonath Studios. I also taught for two years (1962–1963) at the Burnley School of Art, owned by Jess Cauthorn. Other artists teaching there were Sherry and Dick Brown: Sherry later started an art school, which continues today. Also there were James Peck, who had received a Guggenheim Award, Gus Swanberg, and Ted Rand. Caplan and Rand also taught at the University of Washington.

FIGURE
1962
Stoneware
20.5 x 9 x 3 in.
Collection of Dixie Stanton

Having completed an MFA, I tried to make a living as an artist and teacher. I started a small art school, the Phoenix School of Ceramic Art, in which I taught pottery and figure drawing, making my own pottery, sculpture, and drawing. From 1962 through 1963, I made pottery about three months of the year while sculpting nine months. Realizing that I could not raise the level of my pottery by working on an abbreviated schedule, I left working in ceramics. The labor-intensive nature of sculpture, and bronze casting, required that making sculpture be my year-round activity. I was more excited about the potential of bronze as a medium.

My young family resided in the Rainier Vista public housing project until 1964, where our sons Aaron and Jacob were born. There we became acquainted with Neighborhood House, a social service agency that provided a preschool activity for our children and an interface with the larger Seattle community. Rachael served on the Neighborhood House Board of Trustees. In 2005 our son Josh created a fourteen-foot-high sculpture for the new Rainier Vista Neighborhood Center. It was at Neighborhood House that we met Anne Gerber, who became a longtime friend and supporter. As I was participating in the various art exhibits in the area I also met Anne Gould Hauberg, who also was a friend and supporter.

In 1962 I received my first commission after graduation, a life-size figure in concrete for Kim's Broiler, a Seattle restaurant. Another small commission, for Adelaide Elementary School in Federal Way, enabled us to buy a small house in

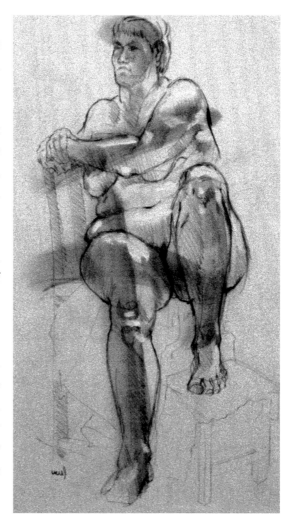

WOMAN
Graphite with wash and gouache
16 x 11 in.

South Seattle. During Rachael's work-related travels to various parent cooperative preschools in the area, she found a house with a big yard and a double garage that would make a good studio. It was located in the Highline School District, which had initiated and embarked on some innovative curriculum at the local school, and we saw this move as advantageous also for our sons.

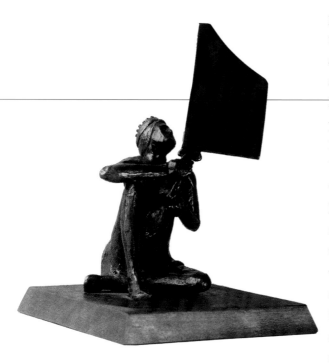

EXCALIBUR 6
1986
Bronze
8 x 5 x 5 in.
Collection of Marjorie Bickel

Other early teaching jobs helped our income. The jeweler and UW professor Ruth Penington had a school for many years, Fidalgo Allied Arts, in La Conner, Washington. I taught one summer workshop in pottery there in 1965 and a bronze casting workshop in 1966. It was there that I met Guy Anderson and Clayton and Barbara James. I lunched occasionally with Guy at one of his studios or at a restaurant. During those times in La Conner, our family dug clams on the beach and soaked up the wonderful Skagit Valley atmosphere.

When I first began casting bronze, an exciting time for me, I met Marvin Herard, a sculptor/ painter, who was teaching at Seattle University, a few blocks from my studio on Pike Street. This studio was the third one I'd had since graduation, and the last one before the studio at home. Marvin had recently returned from a Fulbright year at Bearzi's Fonderia Artistica, in Florence, Italy, and had set up a foundry at Seattle University. A fine sculptor and painter, Marvin was the core person for those of us who were learning the process in the Seattle area. No commercial bronze sculpture foundries existed here at that time. I'd taken the one wax sculpture I made while finishing my graduate work to a foundry owned and run by Red Stuart, who was interested in working with the few of us who wanted to try our hands at local casting. Ray Jensen and I were among the first to work with Red. I would sprue and invest the molds for lost-wax casting and burn out the wax in the ceramic kiln in my school/studio, which was located on the ground floor of an apartment house. The fumes brought the owner, John Kusakabi, downstairs with a request to keep the fans going as long as possible during the burnout process.

I met Ray Jensen at a 1961 ceramic exhibit at the University of Washington's Henry Gallery, where I was showing a ceramic sculpture. Sculptors were not very common in the area in 1961, and the few of us who were around began to band together. A prospectus for an exhibition in those days would ask for submissions by "artists and sculptors." At this time I was asked to join a group called the Northwest Institute of Sculpture.

As I left clay and began to work in bronze casting, I could develop ideas in sculpture that were con-

cerned with the fluidity of the medium and the freedom of forms that it allowed. These forms could be very different from the clay figures I had been doing. The parameters of bronze as a medium so differed from clay that I could design works with a greater movement and balance. It opened the door to a broader expressive range. What could the figure represent in aesthetic forms? What did it imply in content? These questions were now exciting.

In 1965 several of us started the Burien Arts Association. Dorothy Harper, later chairperson of the King County Arts Commission, Marty Gardner, Barbara Jorgensen, John Mulder, and Al Reamer were the primary group. We opened a gallery, still in operation, and also put on several outdoor sculpture exhibitions in the region. At one of those I met the sculptor Tom Jay, who was demonstrating bronze casting. Tom and I installed a foundry outside my studio. Shortly after, I put up a twenty-four by twenty-four foot addition with a twelve-foot ceiling next to the studio to move the foundry indoors.

Other than Tom and Marvin, few of us had much experience in casting. One day as the gang was doing a casting I got a call from grade school saying that my son Jacob was ill and asking me to come get him. I did and found that he was all right: he just wanted to be in on the action! We came back to the studio and saw a new person working on wax sculptures: that's how I met the sculptor Ted Jonsson. The studio was a cluttered place filled with cardboard boxes, newspapers, and sacks of materials. During the casting, sparks flew and things started burning. Rachael climbed

KNEELING WOMAN
Graphite
10 x 8 in.

around with a broom putting out the fires. We later asked any sculptors we knew to come to the studio to experiment with casting.

With the foundry in place I began to do larger works and expand the range of what I could do with bronze and the figure. There is a wonderful paradox and ambiguity about bronze; lightness, grace, and balance achieved through a medium of strength, density, and weight. I wanted to take advantage of bronze's possibilities, its durability and surfaces. I had done a few fabricated sculptures but other than fountains I had abandoned that aesthetic direction. Feeling more comfortable with the figure, I moved forward with the idea of

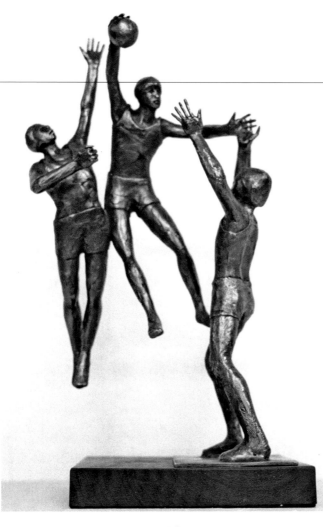

BASKETBALL PLAYERS
1974
Bronze
14 x 9 x 7 in.
Collection of David and Jenny Perine

commissions. The commissions enabled me to do some larger works, although they rarely exceeded life-sized in scale. Having my own foundry let me do larger pieces that were not commissions. My income from art from 1965 to 1980 averaged $5,356 per year. (Figure sculpture was not "art à la mode.") Meanwhile, Rachael had become a full-time instructor in Early Childhood Education at Seattle Central Community College, which enabled us to meet our regular mortgage payments. By 1972 I had begun to push the potentials of working with bronze, and for the next eight years incorporated those factors into my work. Being an "at-home/studio" father meant I could spend time with my sons and their friends—music lessons and kids' softball coaching, hauling the tennis team to various matches, and giving all of them studio time.

By 1980 I began to push forward in the direction I had been touching on in the '70s: changing the technical aspect of lost-wax casting to lost-carbon casting. This process was not new to artists but it had several important advantages for me. As wax is carbon, anything made of carbon may be used to bring the sculpture to the stage prior to the sprueing, investing, burnout, and casting—cardboard, cloth, rope, string, and so on. By working directly with these materials I could create the sculpture. With the older method I had to build an armature, cover that with clay and plaster modeling, then make a plaster or fiberglass mold of the sculpture, then brush or pour wax into the sections of the mold to the desired thickness and join them, then sprueing the waxes, investing them with a plaster, and sand mix, and proceeding

relating the figure to structures. The range of structures could be anything from sports equipment to furniture or buildings.

In the 1970s my income came from occasional jobs—construction work, metal-shop labor, casting for other sculptors, and various sculpture

to the burnout process. You could make sculpture from any material but you would still have to transfer it to mold sections and continue the process.

Creating sculpture involves creative time and labor time. Making the sculpture to cast is creative; the rest is labor. For a larger sculpture under the old system, the ratio was roughly one part creative time to four parts labor time; with the lost-carbon technique it was about 50/50. The lost-carbon process was much more direct, and since the total length of time it takes to make a sculpture is shorter because it is less labor-intensive, it left me more creative time, which gave me more flexibility in the creative process.

Changing techniques makes for changes in the aesthetics. Having a better understanding of the figure and of the capabilities of bronze, I was able to use the figure as a metaphor and image beyond the figure itself. Moving back and forth between these two casting techniques allowed me to look at the work from a fresh point of view each time. And that's what I continue to explore today.

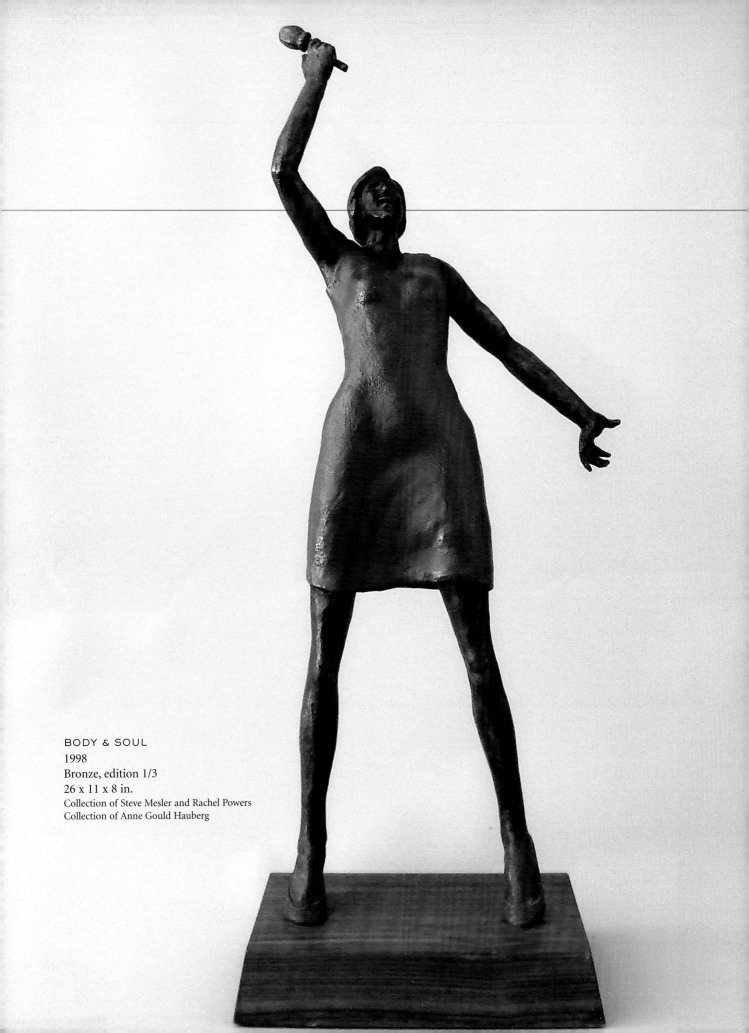

BODY & SOUL
1998
Bronze, edition 1/3
26 x 11 x 8 in.
Collection of Steve Mesler and Rachel Powers
Collection of Anne Gould Hauberg

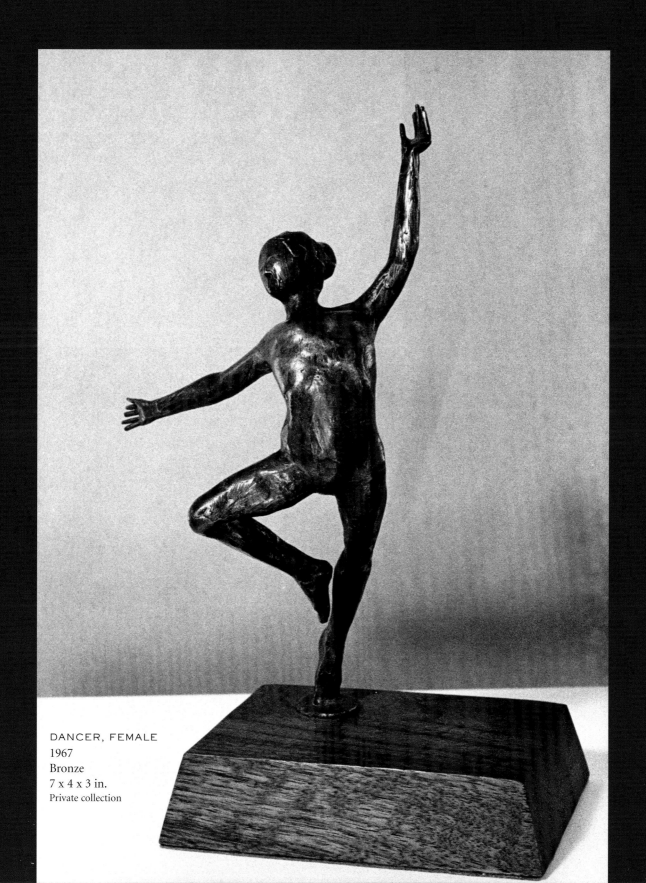

DANCER, FEMALE
1967
Bronze
7 x 4 x 3 in.
Private collection

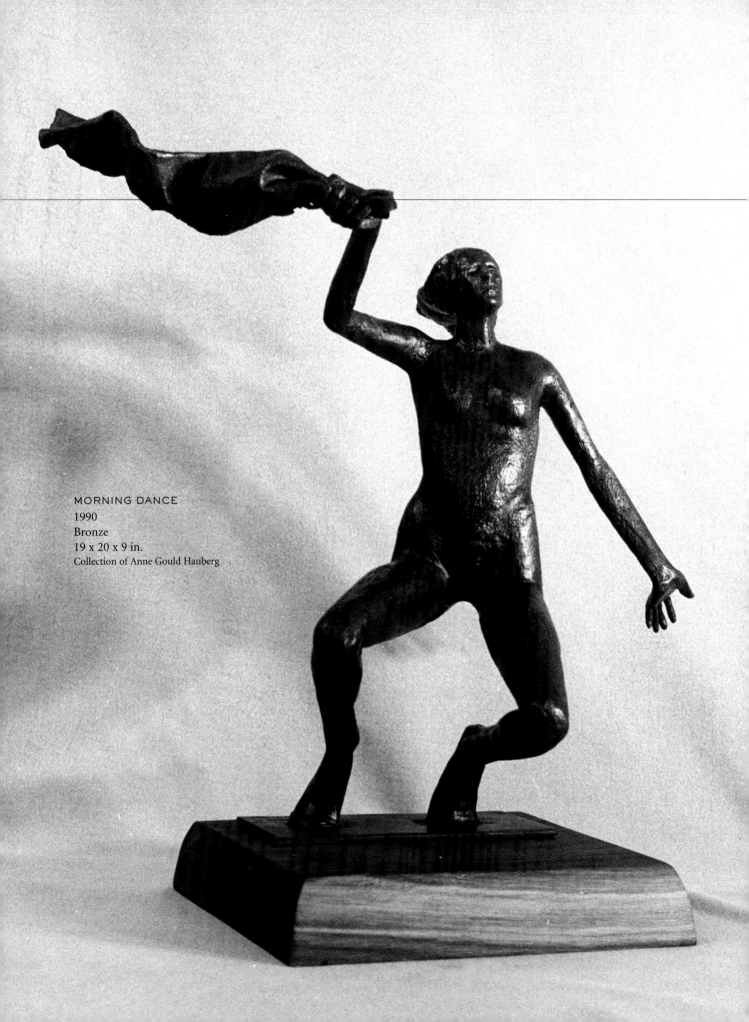

MORNING DANCE
1990
Bronze
19 x 20 x 9 in.
Collection of Anne Gould Hauberg

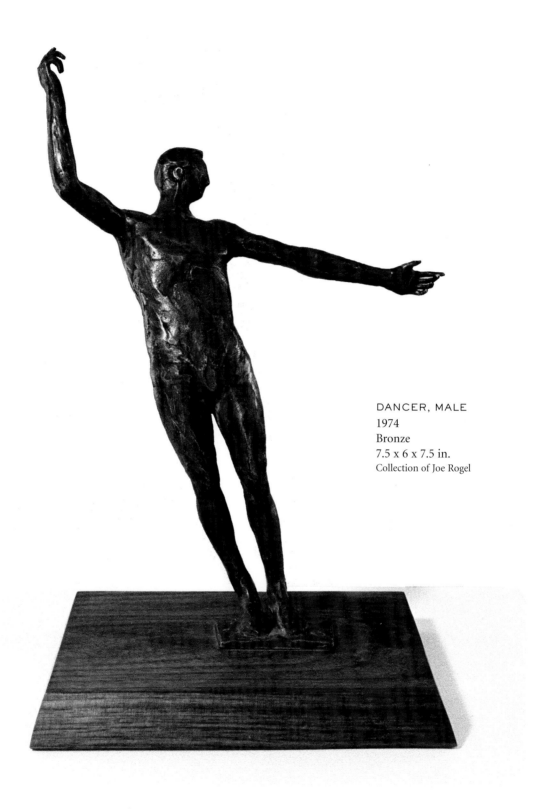

DANCER, MALE
1974
Bronze
7.5 x 6 x 7.5 in.
Collection of Joe Rogel

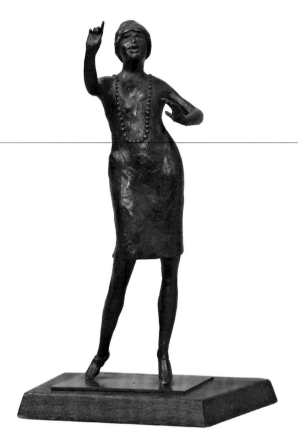

SINGER
1967
Bronze
12 x 4 x 4 in.
Collection of Rachael Levine

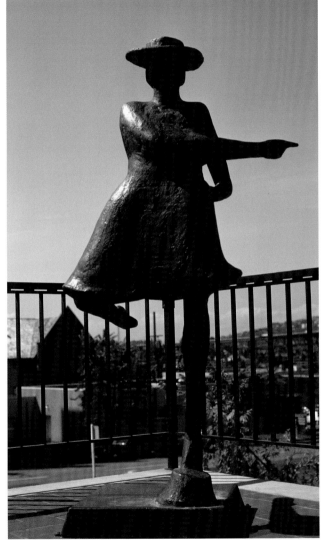

DANCER WITH FLAT HAT
1971
Bronze
78 x 30 x 24 in.
University of Washington
Given by the William Reed Family

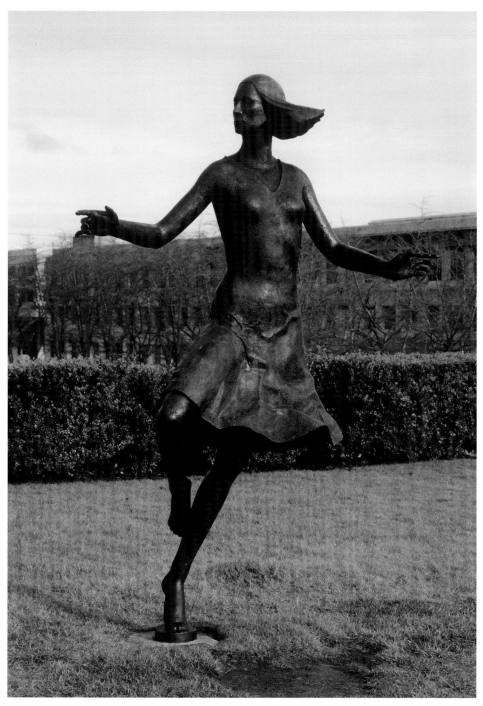

The other sculptors in this project were Tom Jay, James Lee Hansen, James Washington, Jr., and Duane Pasco. The sculpture has been moved twice— once for the Korean War Memorial and then for new capitol construction. It's now located next to a sidewalk near Office Building 2 and the Highway Licenses Building on Capitol Way. This has proven to be the most attractive site of the three.

WOMAN DANCING
1976
Bronze
96 x 58 x 24 in.
East Capitol Campus, Olympia, WA
Commissioned by the Art on the East Capitol
Campus Project, a precursor to the ANSB 1/2% for
Art Program.

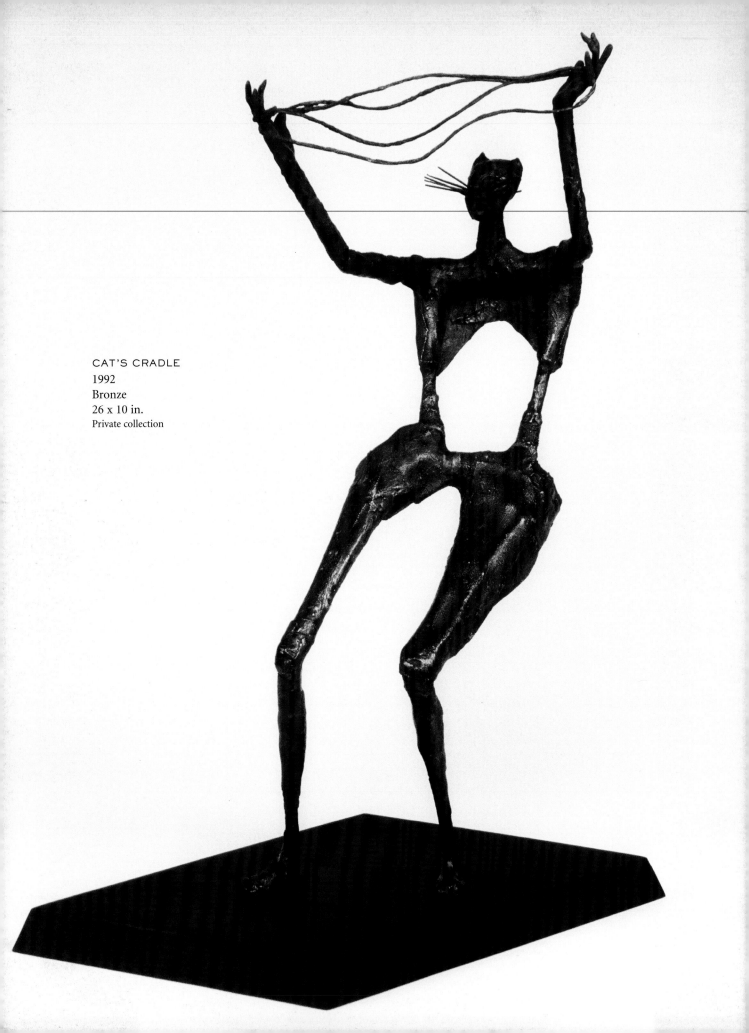

CAT'S CRADLE
1992
Bronze
26 x 10 in.
Private collection

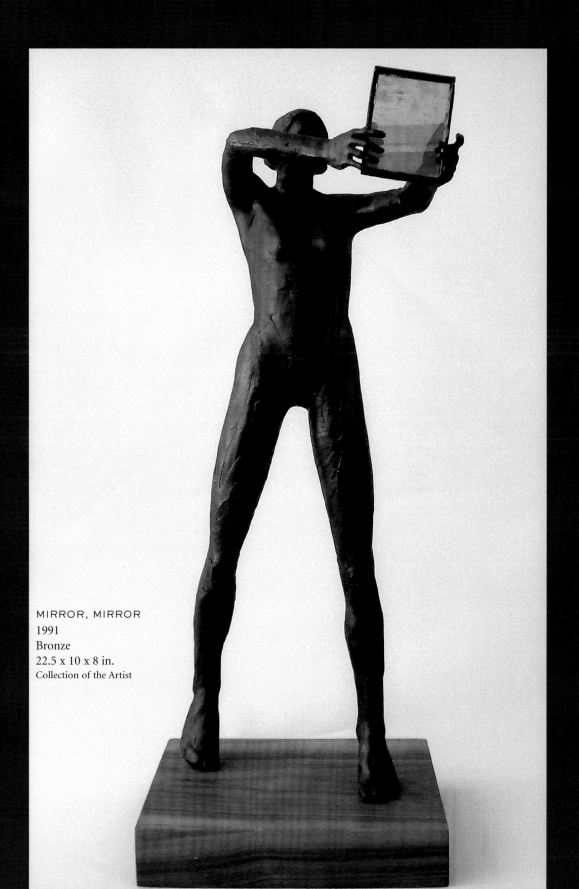

MIRROR, MIRROR
1991
Bronze
22.5 x 10 x 8 in.
Collection of the Artist

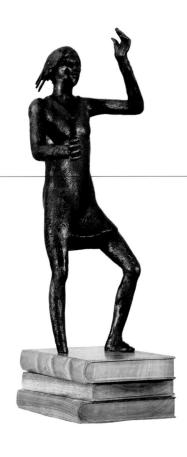

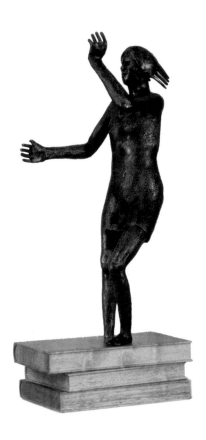

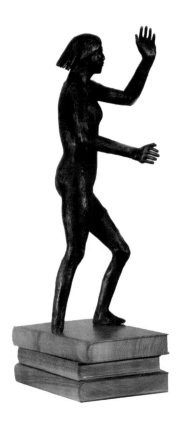

731.456 (three views)
2002
Bronze
22 x 7 x 9.5 in.
Private collection

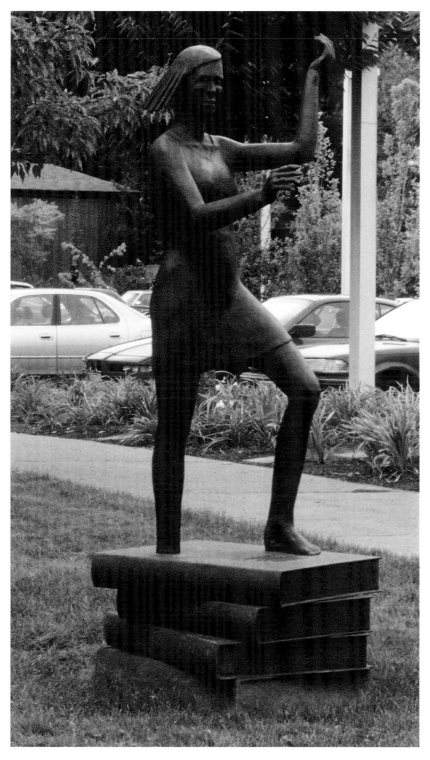

731.456
2002
Bronze
75 x 30 x 31 in.
Books created by Josh Levine
Bothell Regional Library
Commissioned by the King County Arts Commission

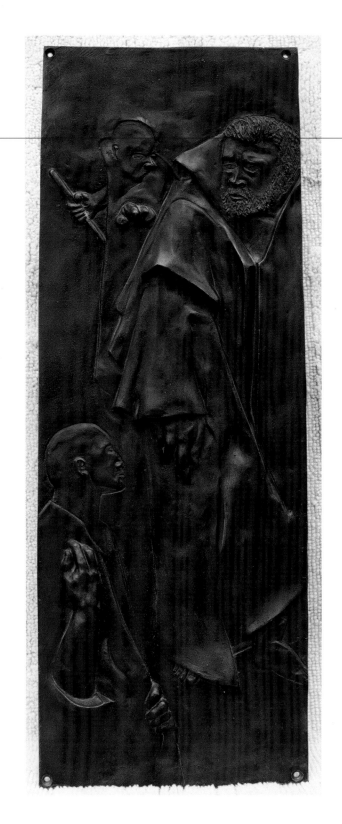

PILATE CONDEMNING JESUS
1959
Bronze
29.75 x 10.75 in.
Collection of the Artist

JANUS
1981–82
Bronze
74 x 20 x 10 in.
Collection of Ted Gardner

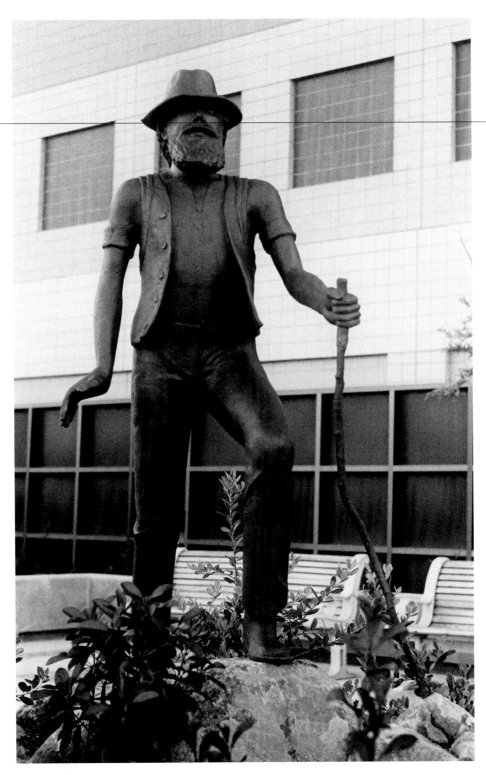

JOHN MUIR WALKING
1988
Bronze
76 x 47 in.
Bird and squirrel by Josh Levine
John Muir Hospital, Walnut Creek, CA
Commissioned by Elizabeth Freeman and the John
Muir Foundation for the new John Muir Hospital.

The commissioners wanted us to use regional granite rocks, so Aaron and I went to the Cold Springs Granite Company in Raymond, CA, to select them. Josh created the squirrel and bird sculptures around the perimeter.

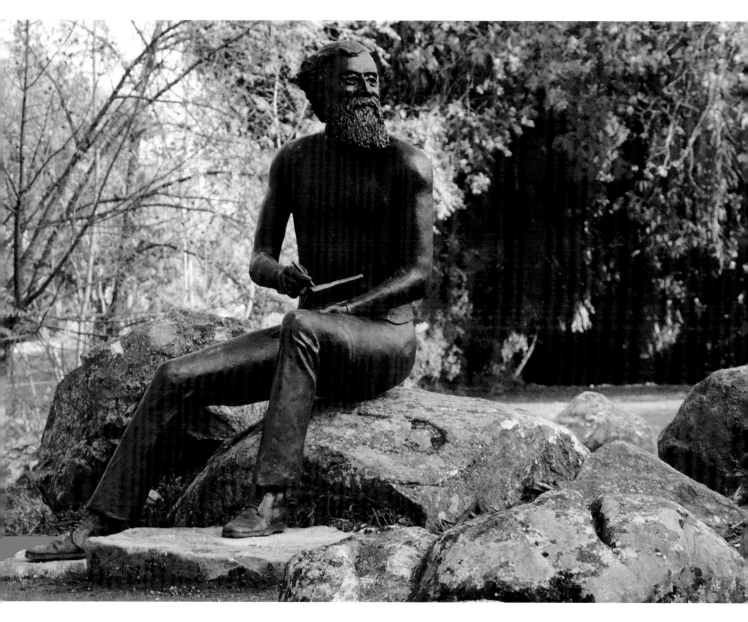

JOHN MUIR SEATED
1990
Bronze
67 x 48 in.
John Muir Park, Martinez, CA

*A few years after the Muir Hospital
sculpture, Shell Oil wanted to honor the
City of Martinez on the 75th
Anniversary of Shell Oil in the city.
Aaron and I returned to the quarry to
select the rocks for the seat.*

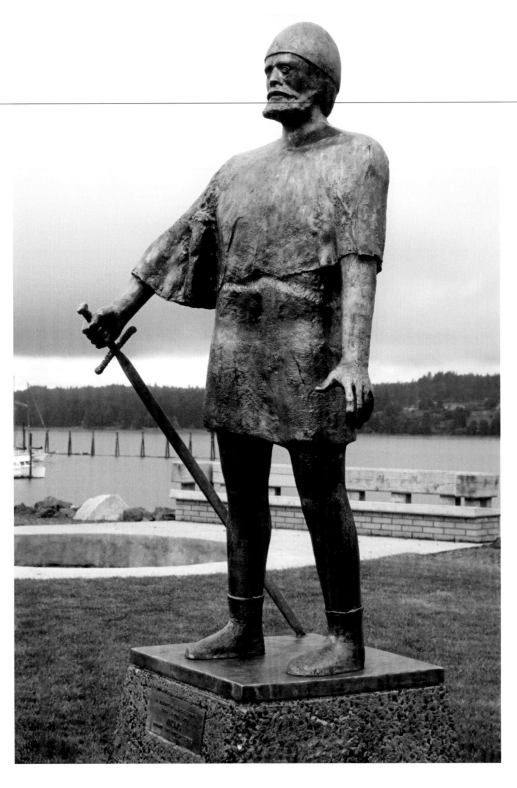

VIKING
1978
Bronze
46.5 x 26.5 x 27.5 in.
Liberty Park, Poulsbo, WA
Commissioned by Mildred Lindvig in memory of
former Mayor Maurice "Morrie" Lindvig

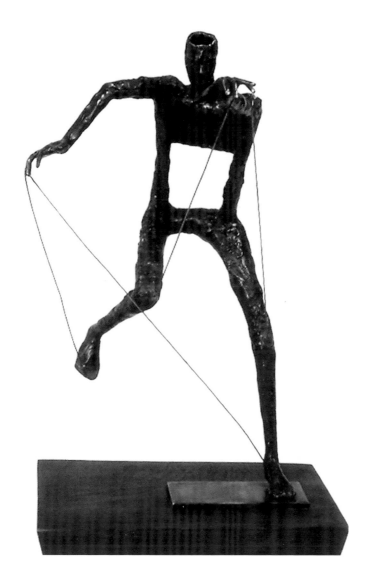

PUPPET MASTER
1991
Bronze
20 x 15 in.
Voyager Middle School, Everett, WA
Purchased by the Washington State Arts Commission

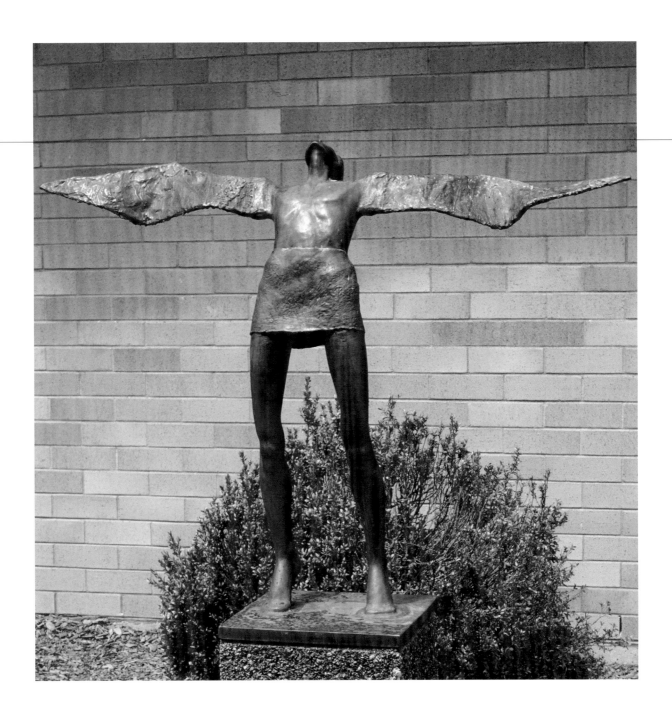

ICARUS
1980
Bronze
43 x 57 x 12 in.
Beacon Hill Elementary School, Kelso, WA
Commissioned by the Washington State Arts
Commission

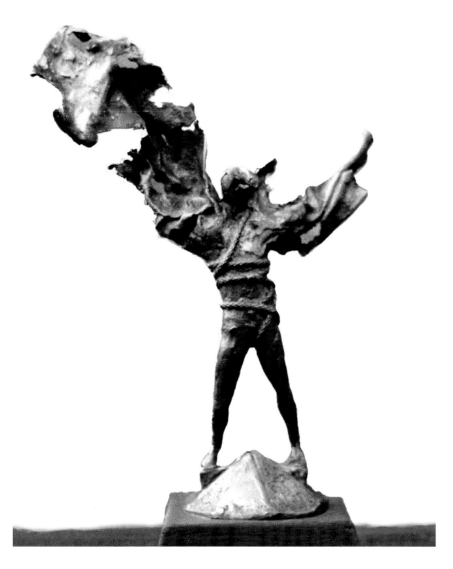

ICARUS CLIPPED
1971
Bronze
10 x 12 x 4 in.
Private collection

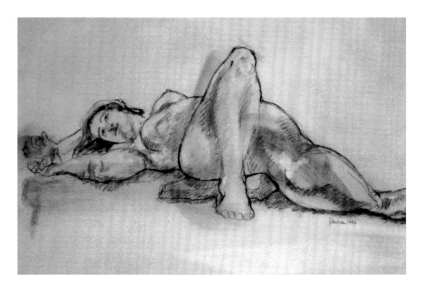

LANGUID FIGURE
Graphite and wash
10 x 17 in.

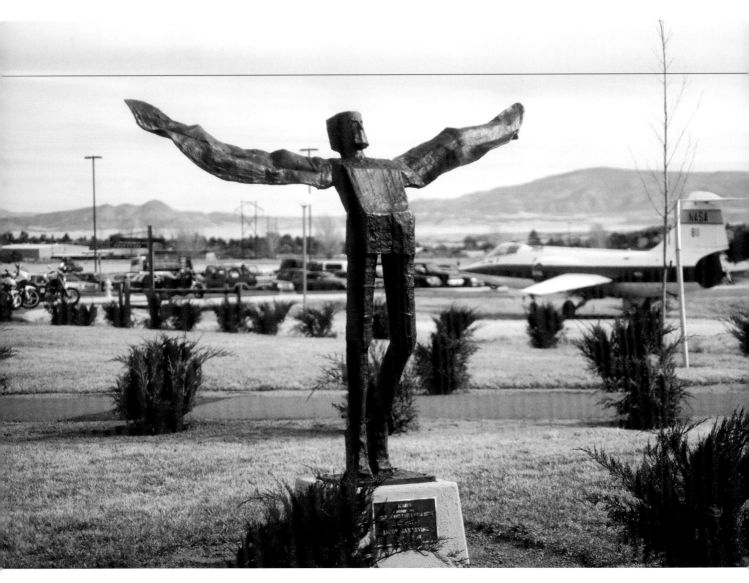

ICARUS
1991
Bronze
62 x 78 x 18 in.
Embry-Riddle Aeronautical University,
Prescott, AZ

Given in memory of our son,
Jacob Max Levine, who grad-
uated from the university. I
had done five different sculp-
tures of Icarus over the years.
This is the last one I created.

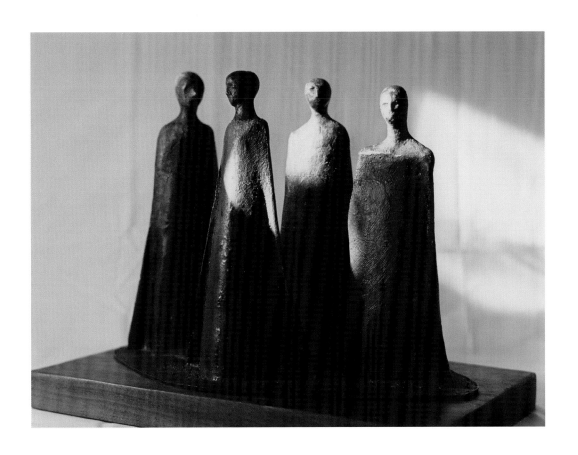

PROPHETS
1963
Bronze
10 x 12 x 8 in.
Collection of the May Family

CONQUISTADOR
1967
Bronze
8 x 4 x 3 in.
Collection of Walter and
Esther Schoenfeld

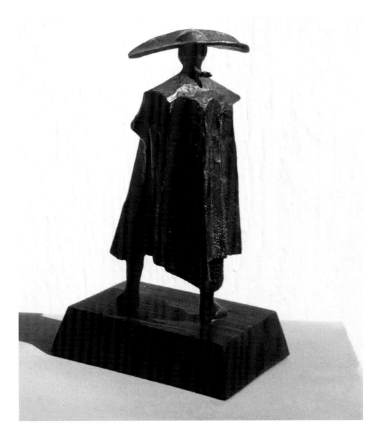

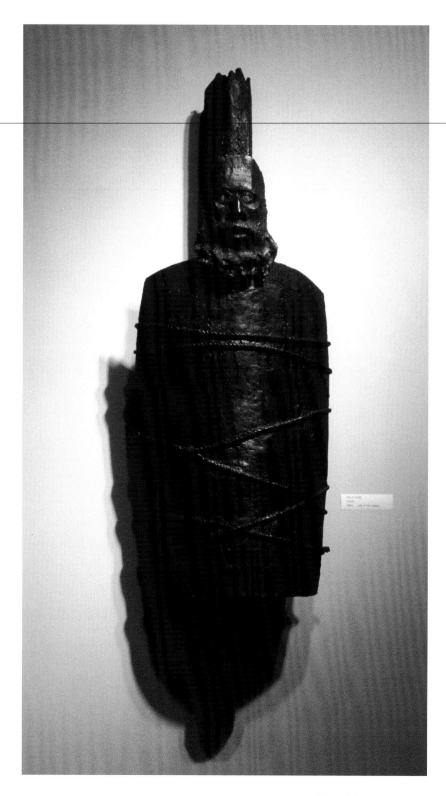

ULYSSES
1972
Bronze
51 x 15.5 x 8 in.
Private commission

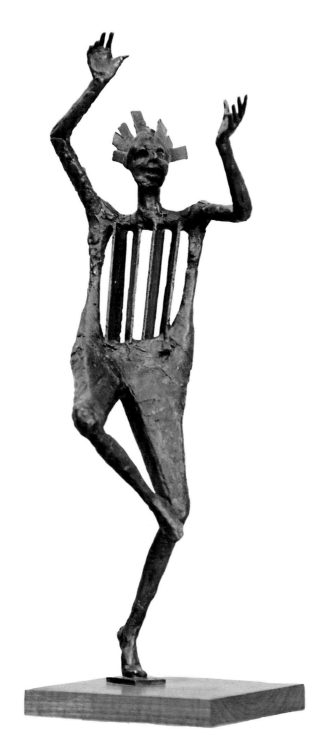

PLAYING THE FOOL
1998
Bronze
28 x 11 in.
Private collection

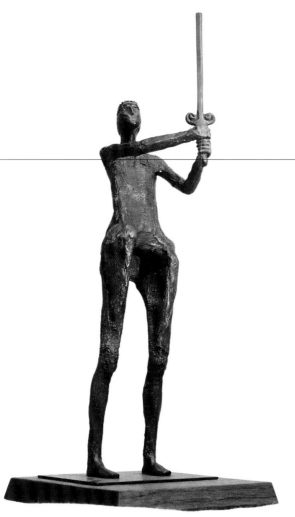

EXCALIBUR 7
1996
Bronze
17 x 5 in.
Collection of Betty Black

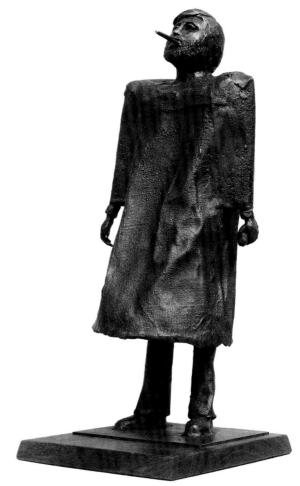

JAMES COFFIN AS VASCO DA GAMA
DISCOVERING THE NEW WORLD
1983
Bronze
18 x 7 in.
Collection of Barbara Coffin

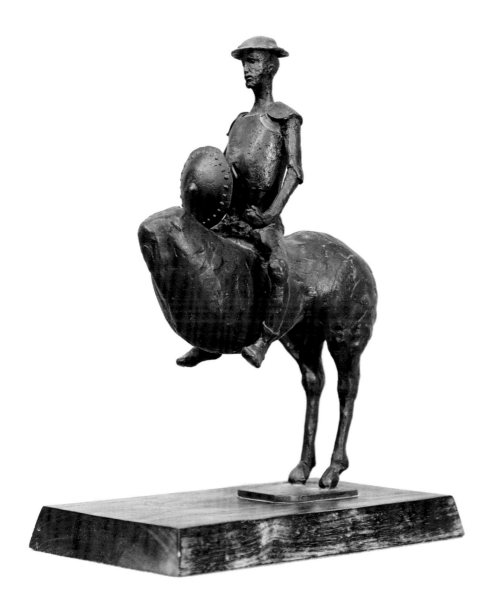

DON QUIXOTE
1961–1969
Bronze, Edition of 2
14.5 x 5 x 9 in.
Collection of Norman Lundin & Sylvia Johnson &
Stephanie and Josh Levine

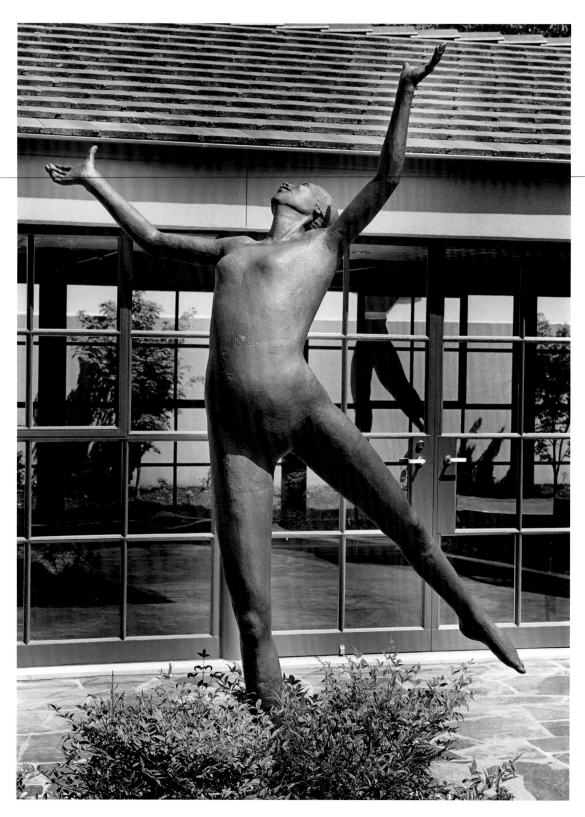

The Shadow *is a bronze plate (96 x 52 in.)*
on the wall outside the swimming pool-
building. Sunrise, *the sculpture, which*
turns, is located in the garden at the center
of the U-shaped residence.

SUNRISE AND SHADOW
1992
Bronze
96 x 52 in.
Collection of Mr. & Mrs. William Whitsell

WOMAN HOLDING
HER HAIR
1983
Bronze
7 x 6 in.
Collection of the Artist

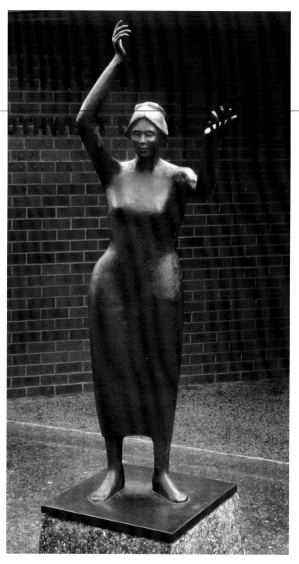

DANCER
1979
Bronze
61 x 24 x 17 in.
Roxbury Police Station and Courts
Purchased by the King County Arts Commission

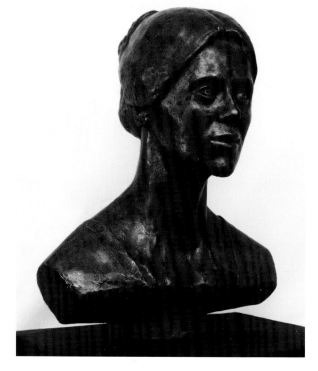

ELIZABETH COLE
1978
Bronze
18 x 15 x 10 in.
Collection of the Artist

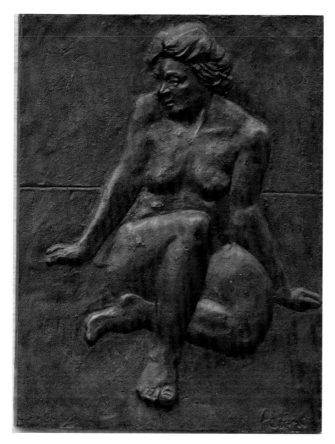

SEATED WOMAN
1962
Bronze
12 x 9 in.
Collection of the Artist

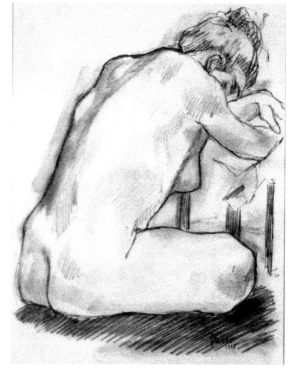

CLOSED
Gtaphite and wash
15 x 14 in.

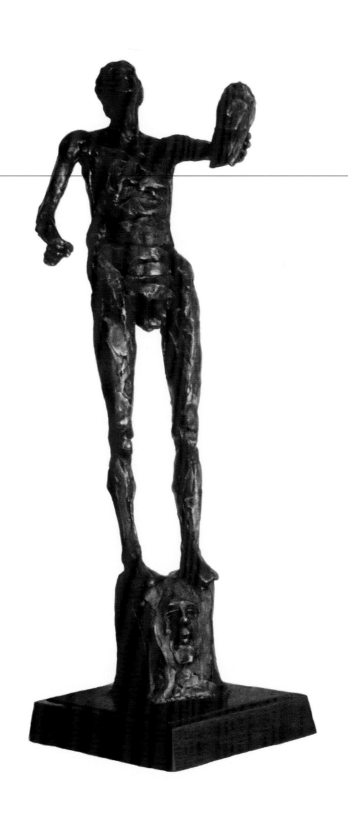

GAMES PLAYER WITH MASK
1990
Bronze
29 x 10 in.
Collection of Sue and John Oliver Perry

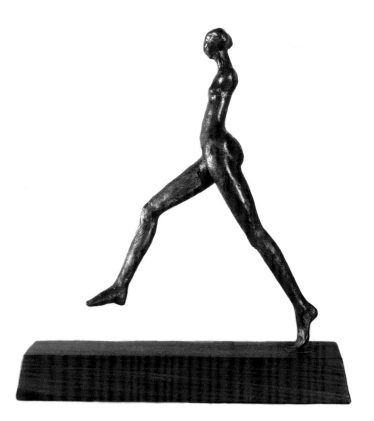

STRIDING WOMAN
1979
Bronze
15.5 x 12 x 3 in.
Private collection

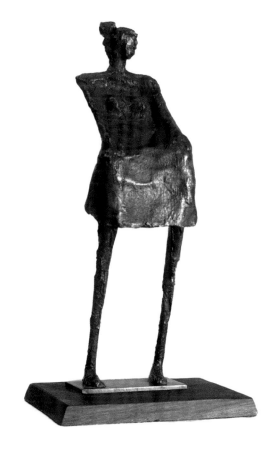

FLOWER CHILD
1991
Bronze
19 x 6 in.
Private collection

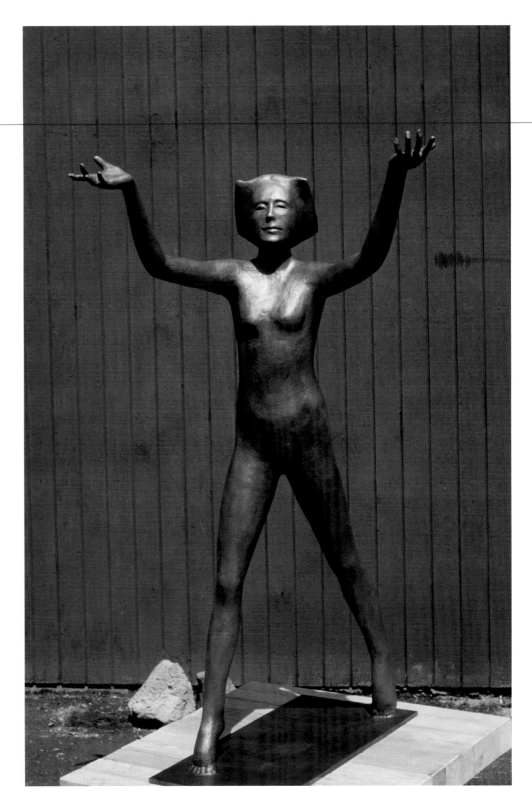

DAUGHTER
1987
Bronze
64 x 36 x 42 in.
Minor and James Medical Building
Seattle, WA

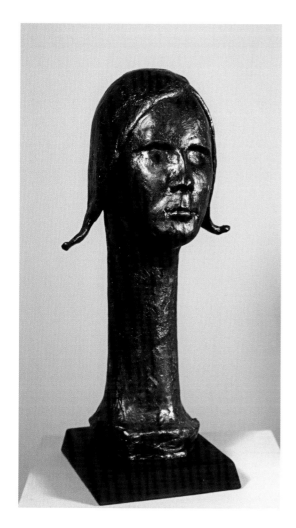

MY TRUE LOVE'S HAIR I
1974
Bronze
19 x 10 x 8 in.
Private collection

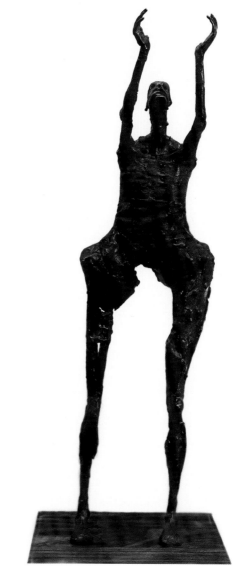

OBBLIGATO 2
1980
Bronze
23.25 x 7 in.
Collection of Patti Warashina

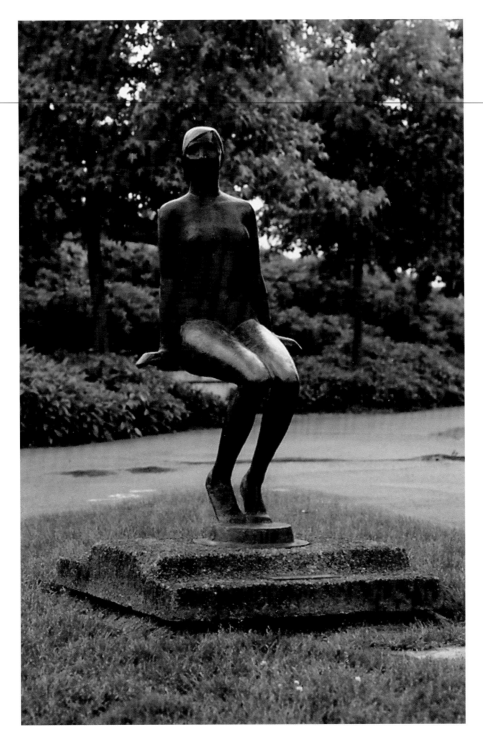

SITTING WOMAN
1970
Bronze
54 x 25 x 24 in.
Purchased by the King County Arts Commission

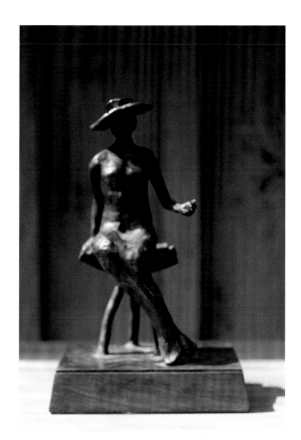

SEATED WOMAN 2
1968
Bronze
9.5 x 4 x 4 in.
Private collection

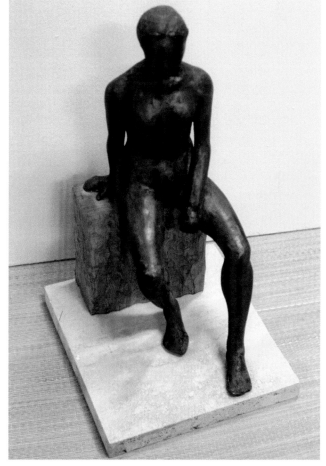

SEATED WOMAN 1
1961
Bronze
13.5 x 4 x 6 in.
Private collection

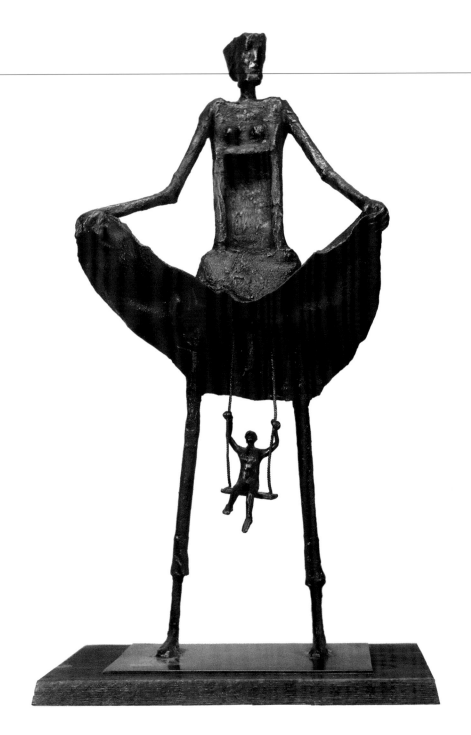

SWINGER SWINGING
1982
Bronze
30 x 15 x 12 in.
Collection of Louise Hoeschen-Goldberg

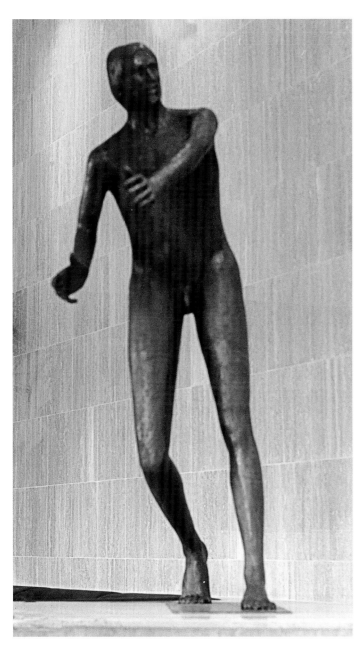

YOUNG MAN
1979
Bronze
61 x 24 x 36 in.
Commissioned by the Bellevue Athletic Club,
repurchased by the artist, exhibited, and then
stolen from another site; the work's where-
abouts are unknown.

LEANING MALE
Ink
11 x 8.5 in.

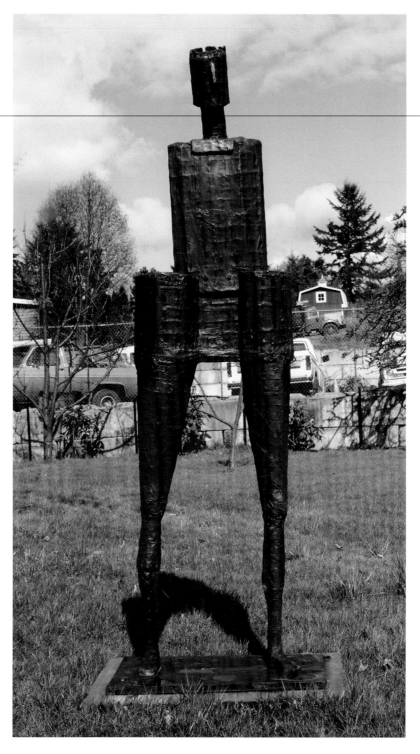

KING
1981
Bronze
104 x 27 in.
Collection of the Rainier Club,
Seattle, WA

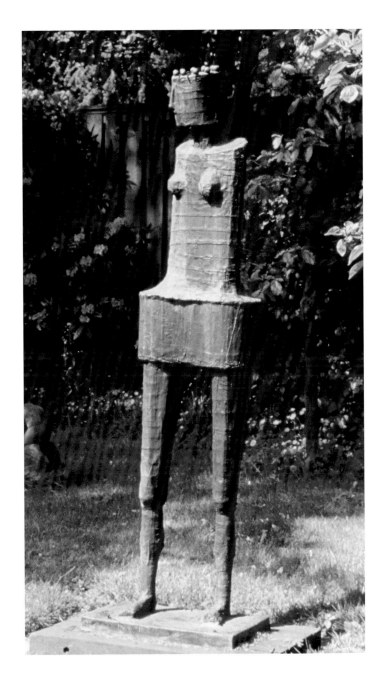

QUEEN
1981
Bronze
80 x 18 in.
Collection of the artist

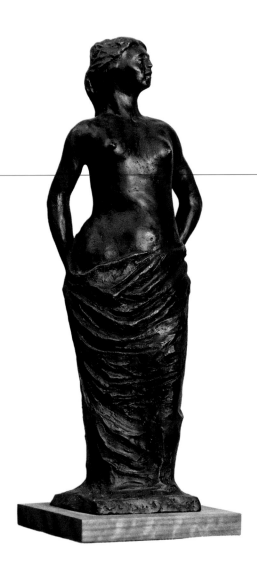

DRAPED WOMAN
1966
Bronze, Edition of 3
24.5 x 9 x 7 in.
Collection of Betty Black
and private collections

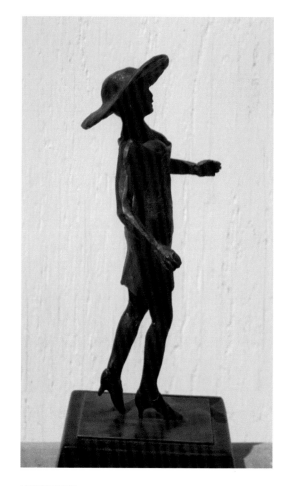

SWINGER
1966
Bronze
8.5 x 3 x 3 in.
Private collection

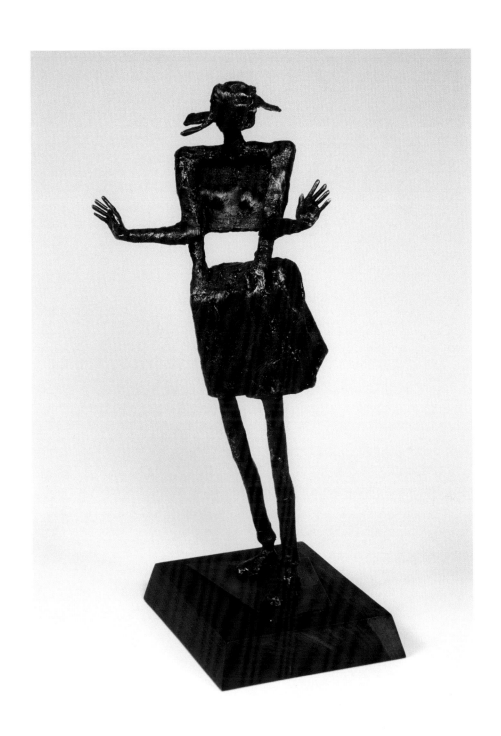

MAIDEN
1991
Bronze
21 x 10 in.
Collection of Greg Yen and Alice Ding

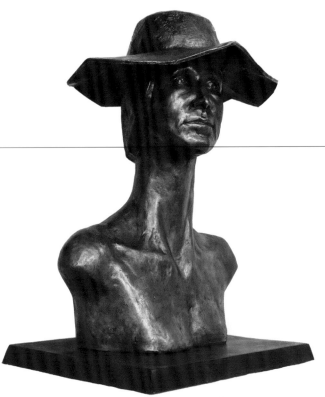

RACHAEL WITH SPRING HAT
1974
Bronze
25 x 10 x 10 in.
Private collection

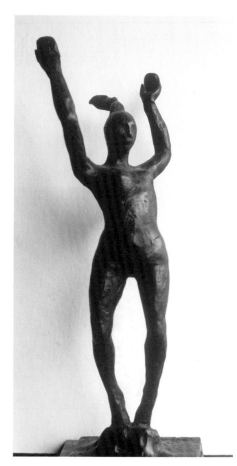

RISING FIGURE
1964
Bronze
11 x 4.5 in.
Collection of Daniel and Alice Cassel

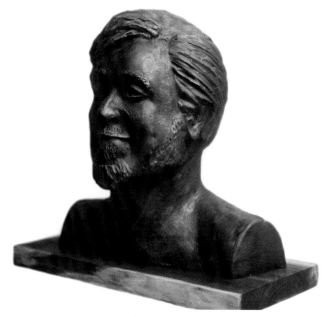

JAMES COFFIN
1985
Bronze
18 x 17 x 10 in.
Collection of the Artist

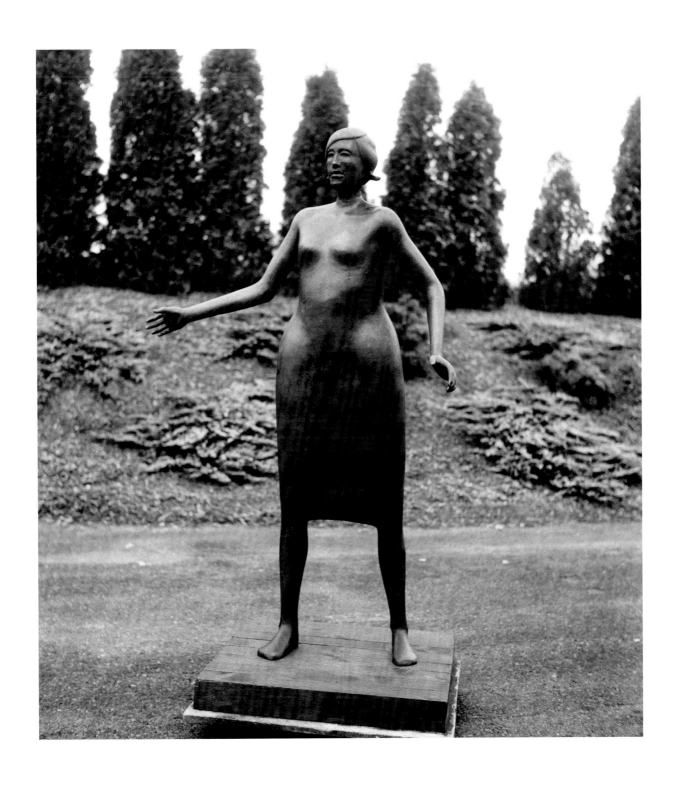

IMAGINED PAST
1981–83
Bronze
66 x 42 x 18 in.
Collection of Barbara and Grant Winther

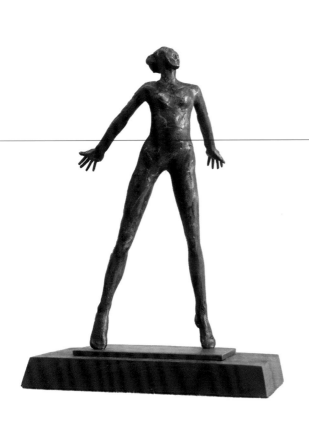

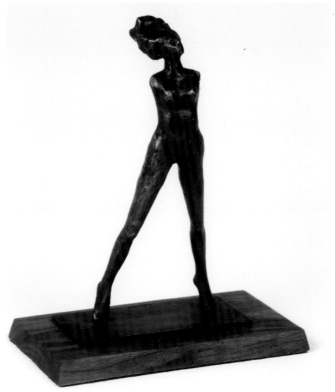

FIGURE SEATED
Graphite with wash and gouache
15 x 10 in.

ASCENDING FIGURE
1991
Bronze
9.5 x 5 x 3 in.
Collection of Michael Altenberg

BIFURCATED FIGURE
1991
Bronze
10 x 4.5 x 3 in.
Collection of the artist

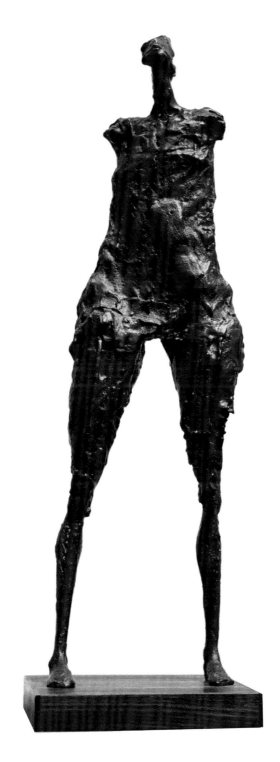

MONOMACHIST
1980
Bronze
32 x 9 x 6 in.
Collection of Ray and Glorea Jensen

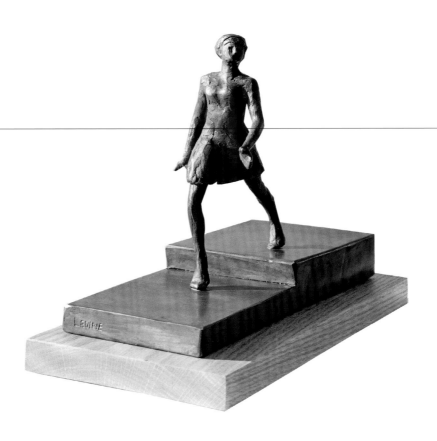

LONG STEPS
1997
Bronze
11.5 x 4 x 10 in.
Collection of Marjorie Bickel

WOMAN WITH STOCKINGS
Graphite with wash and gouache
10.5 x 13 in.

WHEN ONCE WE WORSHIP
Bronze
1992
33 x 9 x 9 in.
Collection of artist

WOMAN ON ONE FOOT
Graphite with wash
14 x 8.5 in.

SITTING WOMAN
Graphite
10 x 8 in.

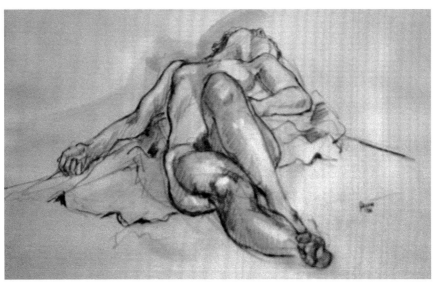

ON BLANKET
Graphite with wash and gouache
11 x 17 in.

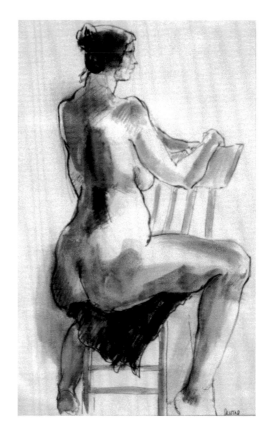

BACK VIEW
Graphite with wash
14 x 11 in.

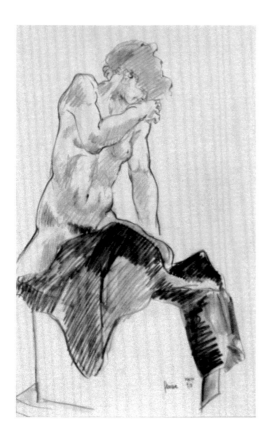

BOX AND BLANKET
Graphite with wash
14 x 10 in.

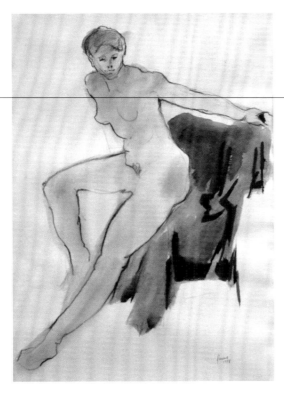

SEATED WOMAN I
Graphite with wash
13 x 10 in.

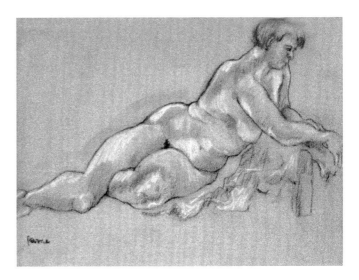

RECLINING WOMAN
Charcoal and conte
10 x 13 in.

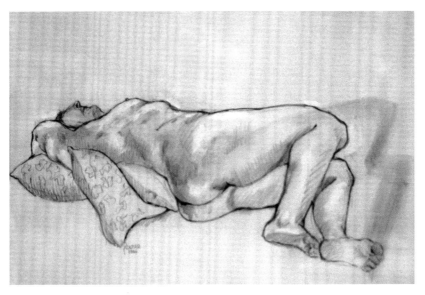

PILLOW SUPPORT
Graphite with wash and gouache
11 x 17 in.

ARM REST
Graphite with wash
10 x 12 in.

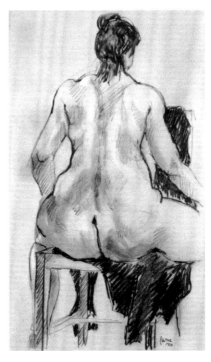

SEATED WOMAN
Graphite with wash and
gouache
17 x 11 in.

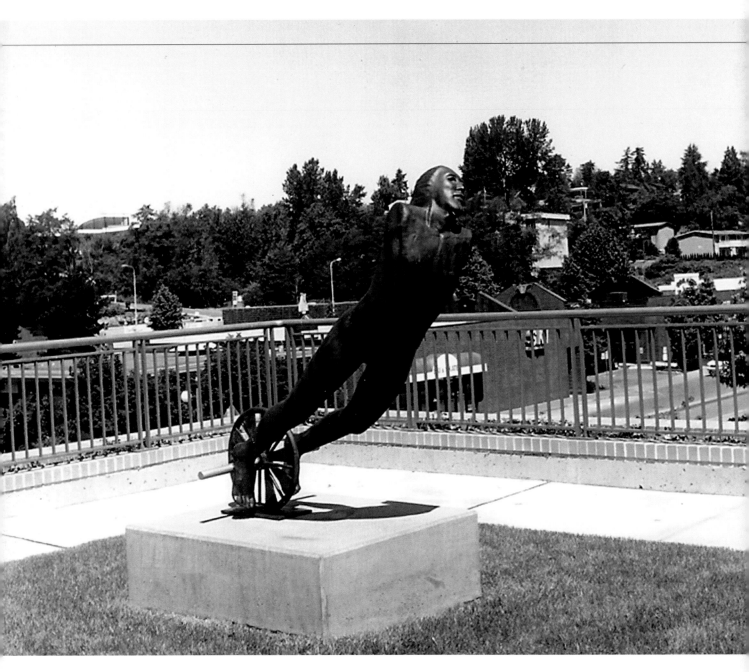

FLASH
1996
Bronze
48 x 72 x 28 in.
Collection of the artist

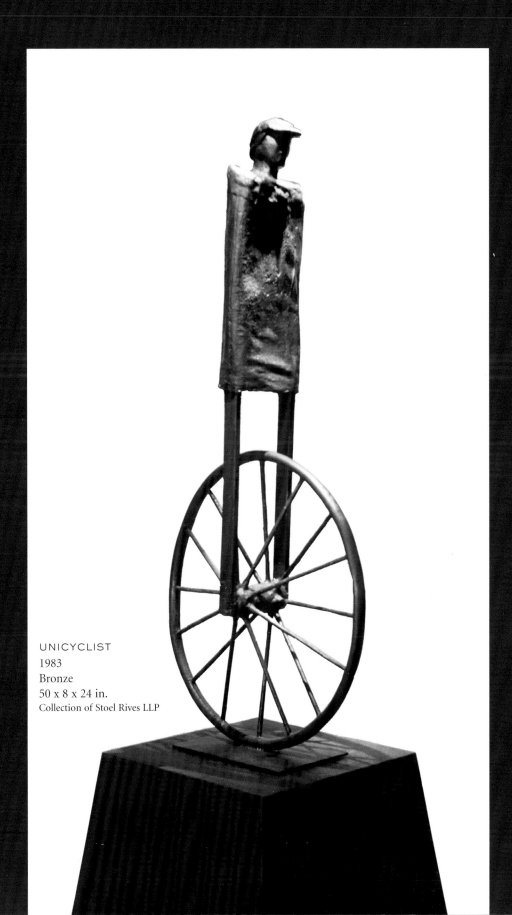

UNICYCLIST
1983
Bronze
50 x 8 x 24 in.
Collection of Stoel Rives LLP

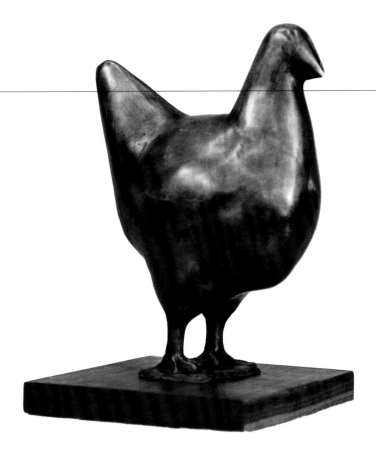

CHICKEN
1965
Bronze, Edition of 5
15 x 5 x 10 in.
Collection of Anne Gould Hauberg
and other private collections

WOMAN WITH SHAWL
Graphite
10 x 8 in.

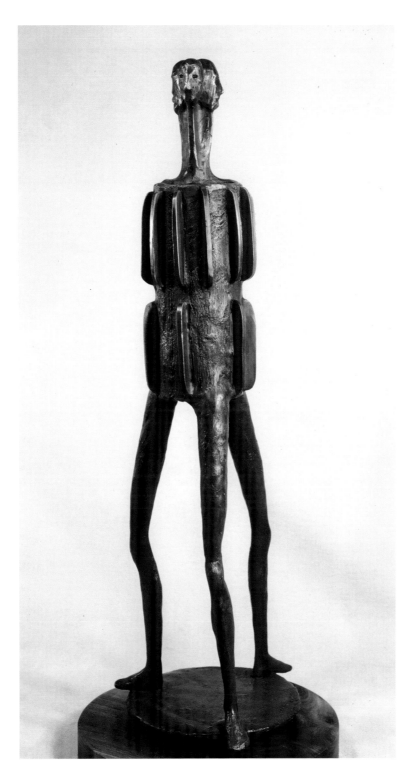

PRE TECH
1986
Bronze
25.5 x 9 in.
Collection of Don and Wanda Stein

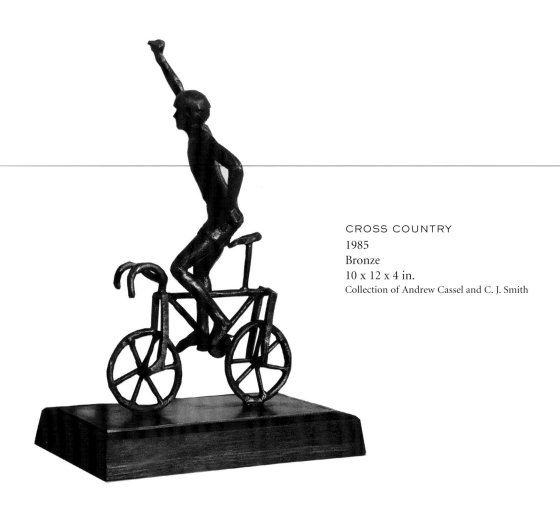

CROSS COUNTRY
1985
Bronze
10 x 12 x 4 in.
Collection of Andrew Cassel and C. J. Smith

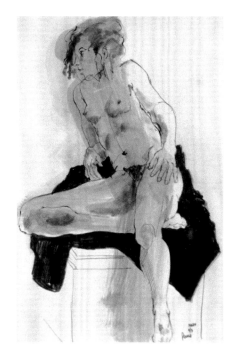

MICHAELA
Graphite with wash
17 x 11 in.

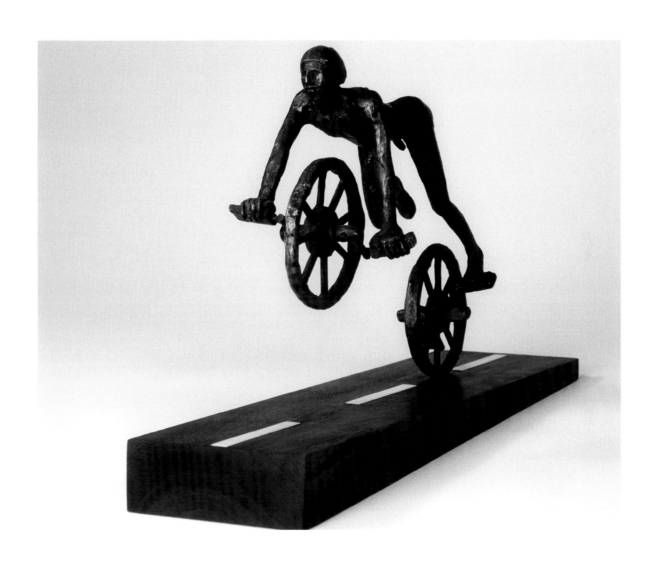

A WAY TO TRAVEL
1992
Bronze and ivory
9.5 x 11 x 4 in.
Collection of the artist

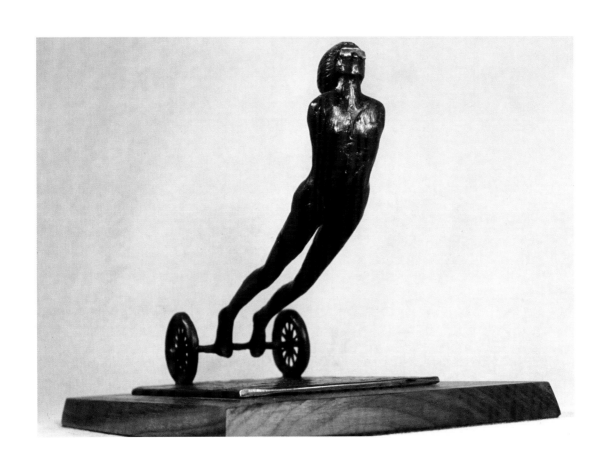

CYCLIST
1986
Bronze
8 x 5.5 x 9 in.
Private collection

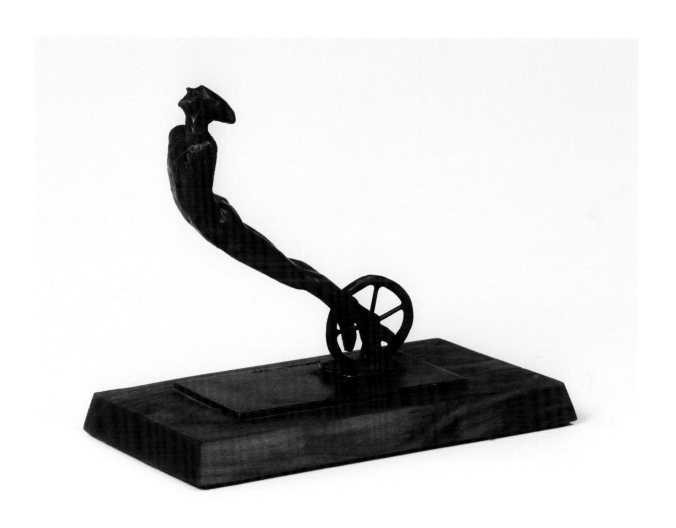

FLASH
1996
Bronze
48 x 72 x 28 in.
Collection of Marjorie Bickel

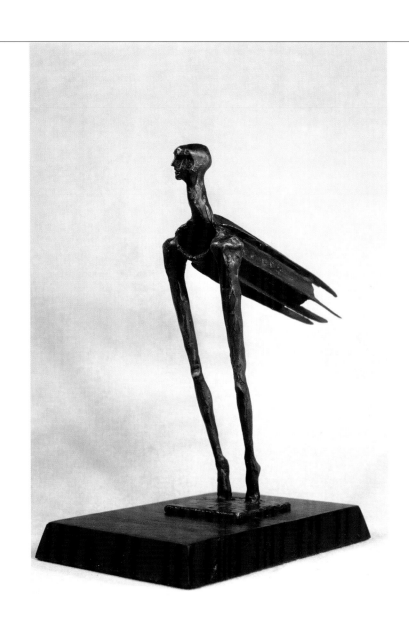

POST HISTORY OF FLIGHT I
1986
Bronze
10 x 3 x 7 in.
Private collection

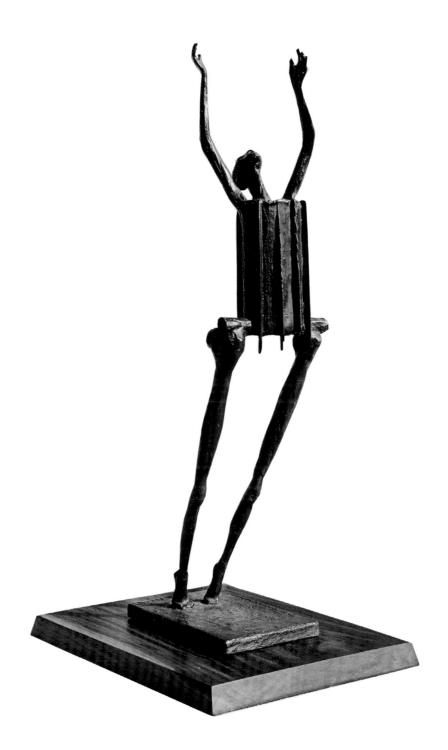

POST HISTORY OF FLIGHT 2
1986
Bronze
20 x 5 x 6 in.
Collection Anne Gould Hauberg

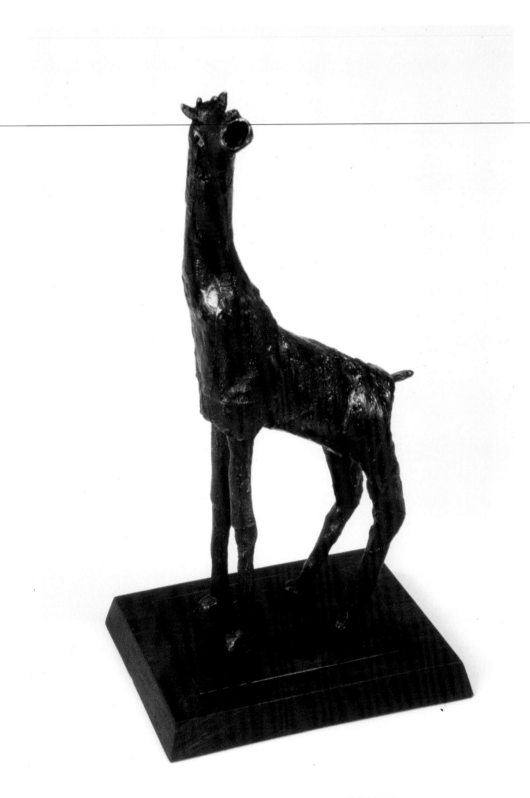

GIRAFFE
1991
Bronze
19 x 8 x 4 in.
Collection of Valarie Baker

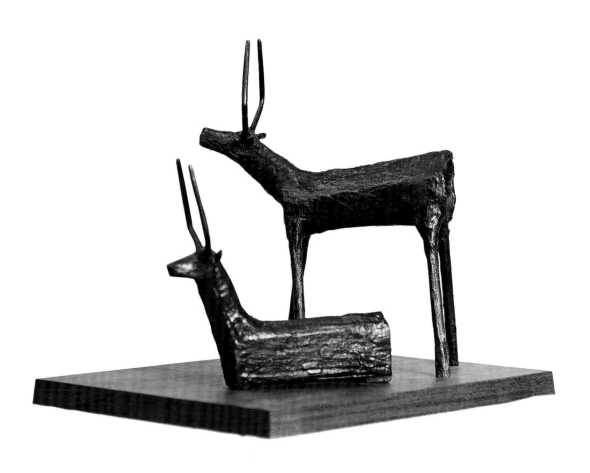

CARIBOU
1986
Bronze
13 x 14 x 4 in.
Collection of the Artist

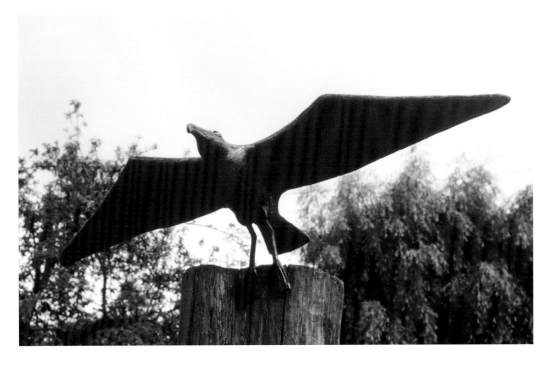

GULL
1973
Bronze
48 x 20 in.
Highline Swim Pool, Des Moines, WA
Commissioned by the King County Arts Commission

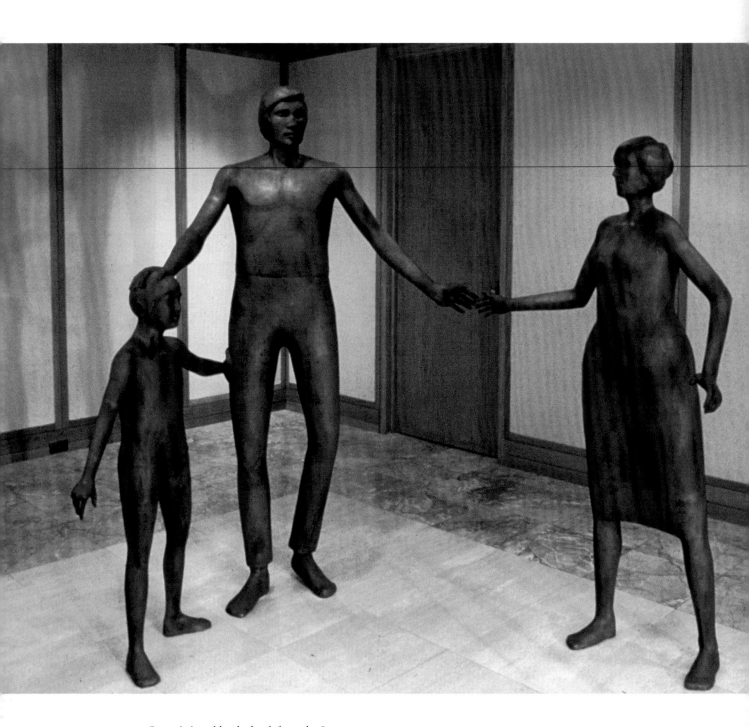

Commissioned by the bank from the Source Gallery. We had only one night to install the sculpture. Members of my interesting crew were Toni Danzig, the gallery owner; an architectural model maker; John Madden, an airline pilot who drove the sculpture to California with me; John Phillips, a lawyer; and my wife, Rachael.

FAMILY
1981
Bronze
74 x 84 x 72 in.
Hibernia Bank
San Francisco, CA

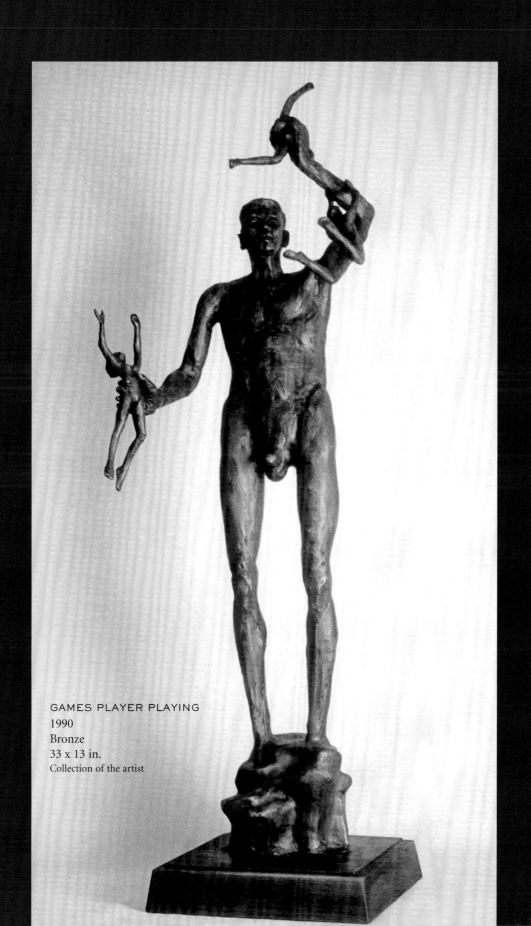

GAMES PLAYER PLAYING
1990
Bronze
33 x 13 in.
Collection of the artist

INTERFACE
(side view)

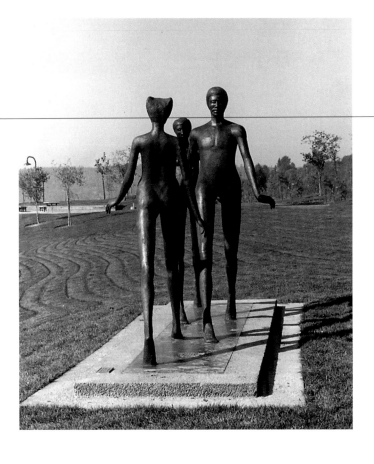

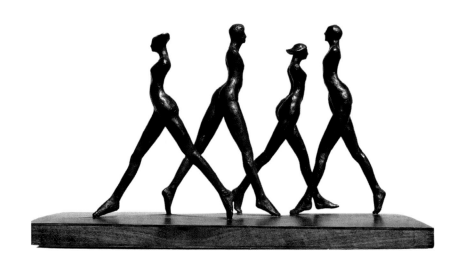

INTERFACE
1975
Bronze
10 x 19.5 x 9.25 in.
Collection of Dr. Abby and Myra Franklin

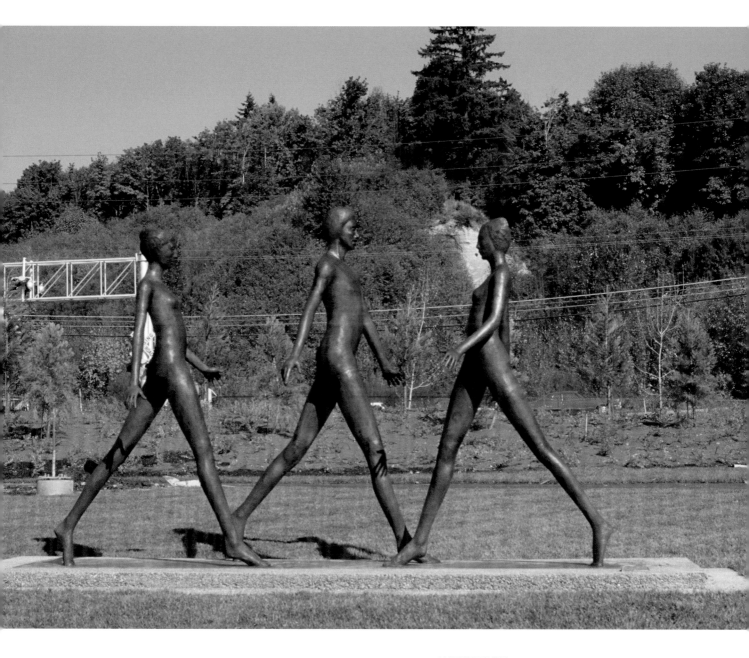

*Renton Mayor Barbara Shinpoch called the
figures "dressed nude."*

INTERFACE
1982
Bronze
84 x 108 x 48 in.
Gene Coulon Memorial Beach Park, Renton, WA
Commissioned by the Renton Arts Commission

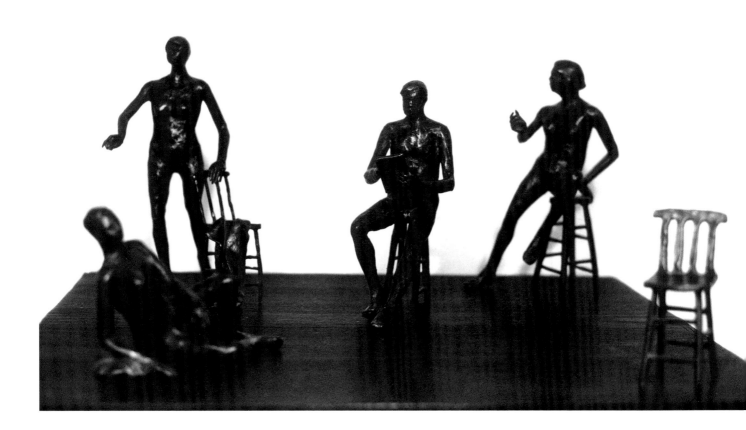

ARTIST AND MODELS
1970
Bronze
9.5 x 20.5 x 22 in.
Collection of the artist

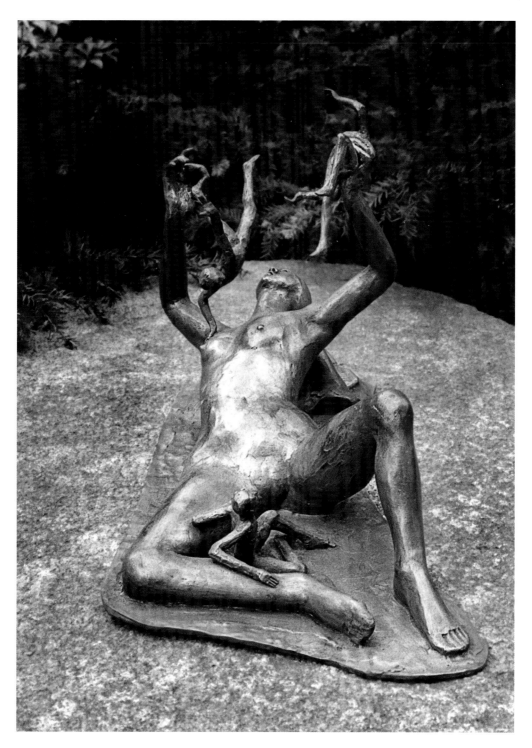

CATAFALQUE
1968
Bronze
12 x 20 x 13 in.
Private collection

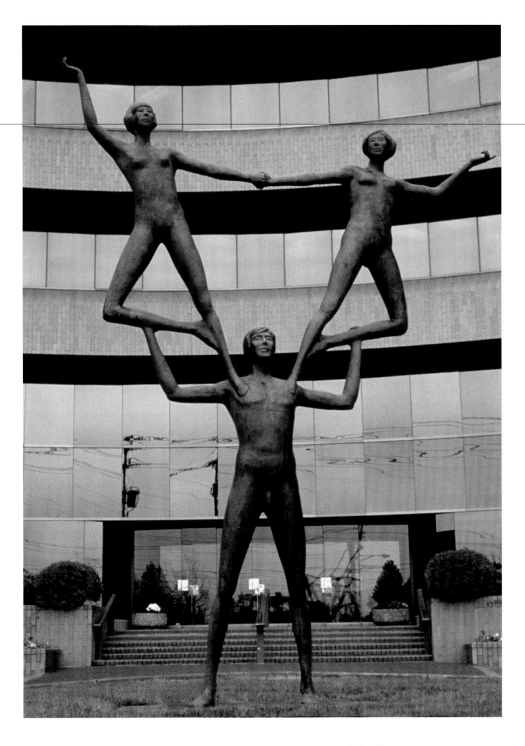

TRIAD
1983
Bronze
168 x 126 x 36 in.
300 Elliot Avenue W, Seattle, WA
Commissioned by Martin Selig

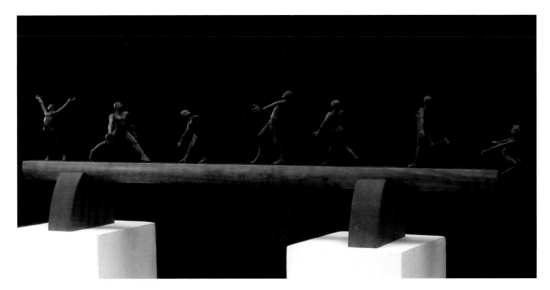

BOARD WALKERS
2006
Bronze
15 x 58 x 9 in.
Collection of the artist

NIGHT WING
1967
Bronze
13 x 7 x 8 in.
Private collection

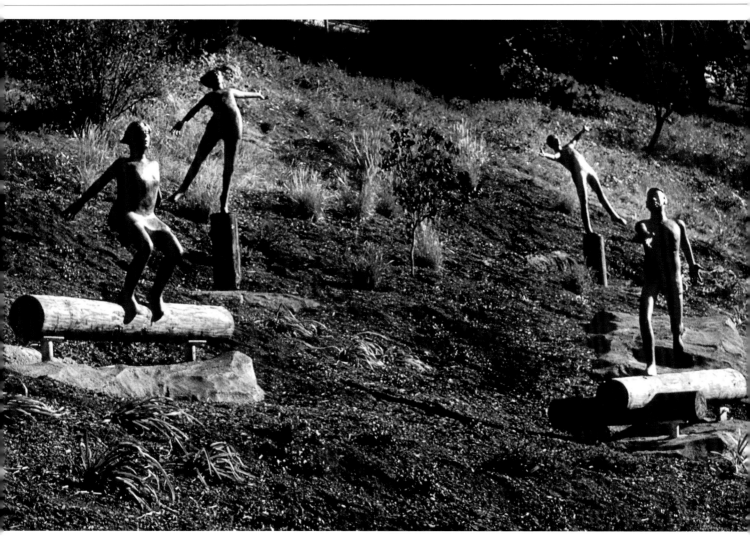

This was an opportunity to do a sculpture in memory of a friend, Hub Miller, a marvelous musician and composer who worked with the Joffrey Ballet and created a musical piece called "Walking on Logs."

WALKING ON LOGS (HILLSIDE)
1996
Bronze and wood
Figures, each over 60 in.
West Seattle Freeway
Commissioned by the Murals of West Seattle.

WALKING ON LOGS
1989
Bronze and wood
20.5 x 25 x 12 in.
Collection of Paccar Corporation

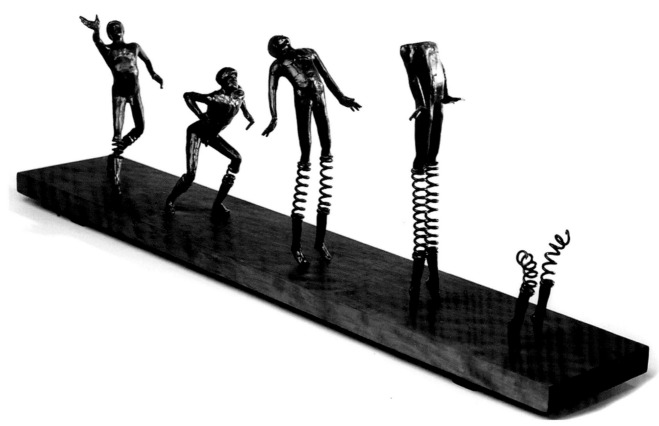

QUEST
1986
Bronze
11 x 35 x 6 in.
Roosevelt Elementary School, Vancouver, WA
Purchased by Washington State Arts Commission

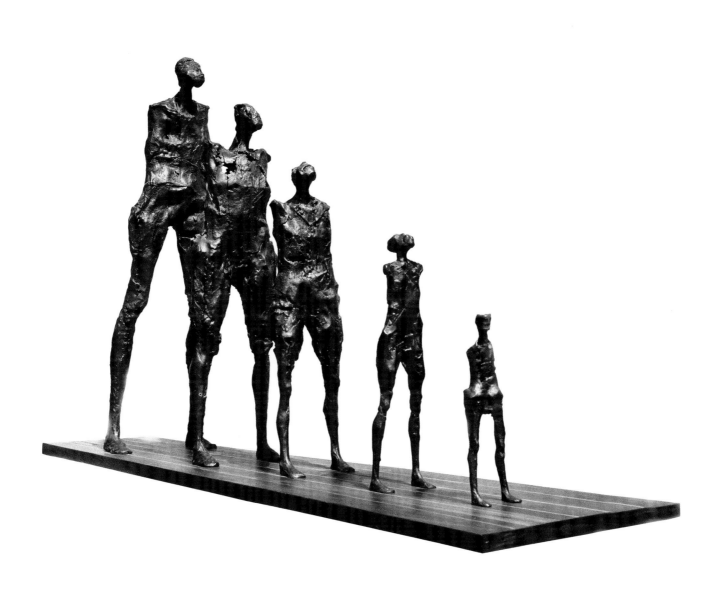

ENTROPIC REACTION
1980
Bronze
28 x 48 x 12 in.
Collection of the Artist

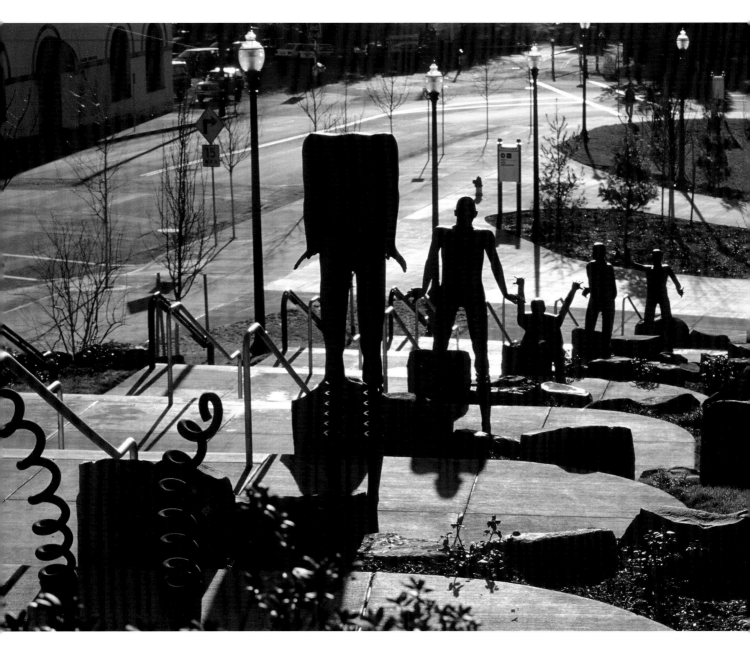

LEAP

1995

Bronze, stainless steel, and steel

Figures approx. 108 in. x 140' going up stairs

Spokane Veterans' Arena, Spokane, WA

Commissioned by the Spokane Public Facilities
District

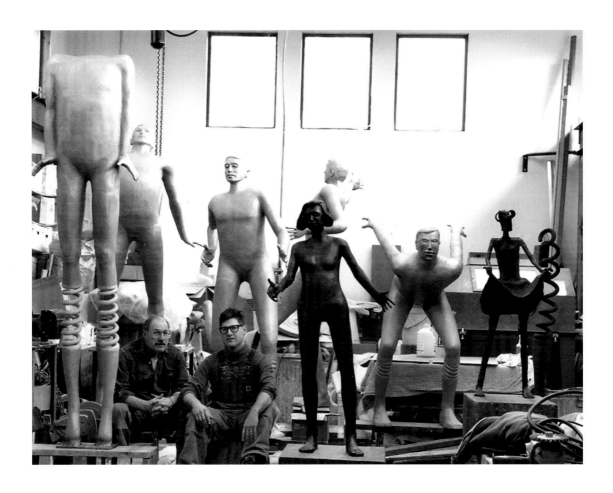

Phillip Levine and Josh Levine in studio with
Leap, prior to patination

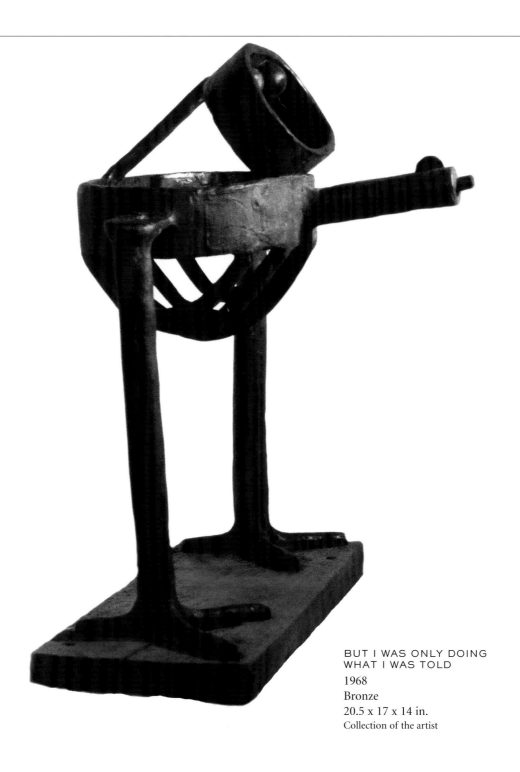

BUT I WAS ONLY DOING
WHAT I WAS TOLD
1968
Bronze
20.5 x 17 x 14 in.
Collection of the artist

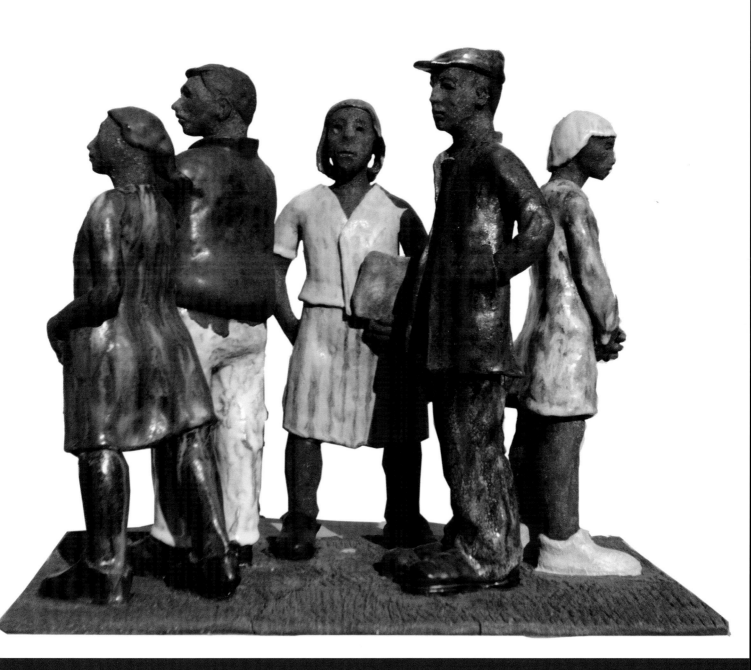

MARKET FIGURES
1965
Stoneware
19 x 20 x 20 in.
Plaza 5 Restaurant, Seattle, WA
Commissioned through Roland Terry, Architect

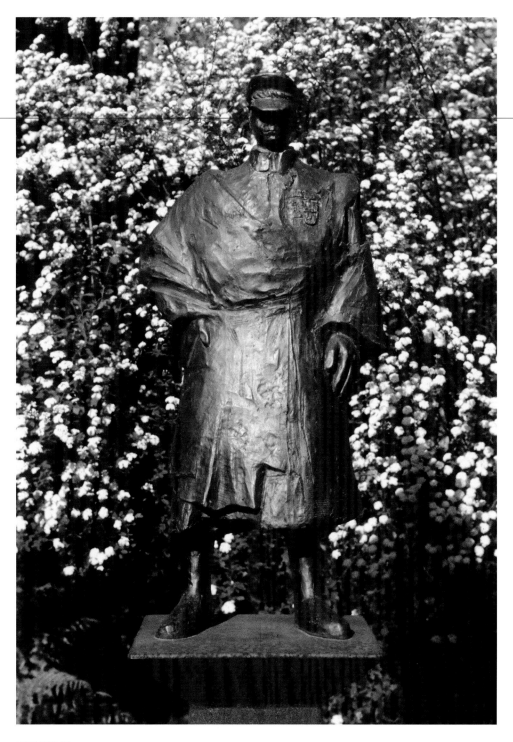

GENERAL
1970
Bronze
31 x 11 x 8 in.
Collection of Louise Hoeschen-Goldberg

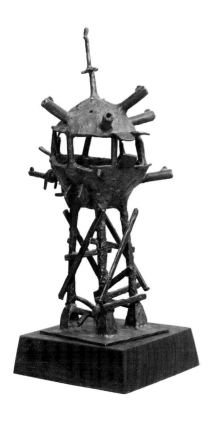

WAR MACHINE 1
1969
Bronze
14 x 8 x 6 in.
Collection of the artist

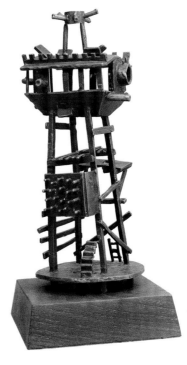

WAR MACHINE 2
1970
Bronze
14 x 7 x 6 in.
Collection of the artist

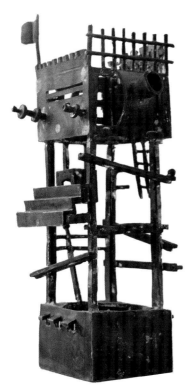

WAR MACHINE 3
1970
Bronze
15.5 x 6 x 5 in.
Collection of Susan Leslie and
John Rollins

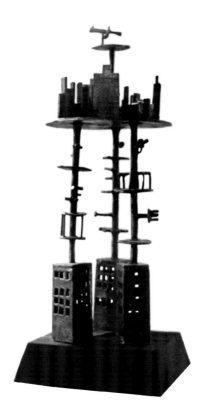

WAR MACHINE 4
1970
Bronze
16.5 x 7 x 7 in.
Collection of the artist

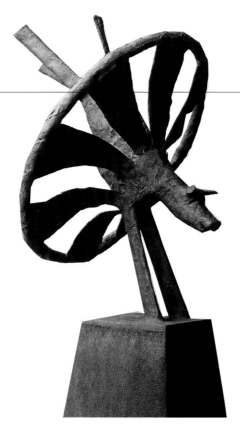

MOMENT OF ENLIGHTENMENT
1986
Bronze
19 x 6 in.
Collection of Judy and Aaron Levine

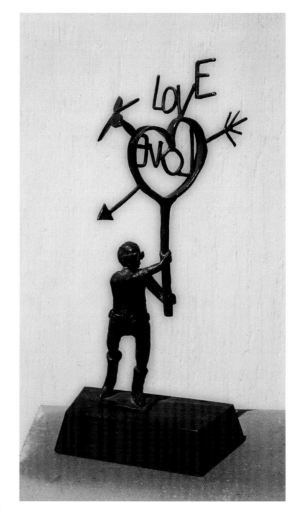

LOVE
1968
Bronze
14 x 8 x 4 in.
Private collection

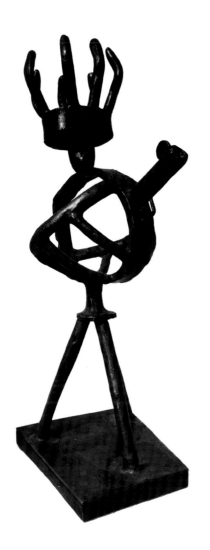

SENTINEL 5
1968
Bronze
18 x 7 x 10 in.
Collection Ken and Nancy Hendry

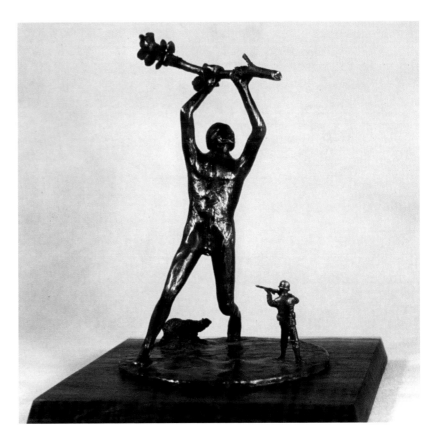

DON'T FEED THE ANIMALS
1986
Bronze
10 x 9 in.
Collection of the artist

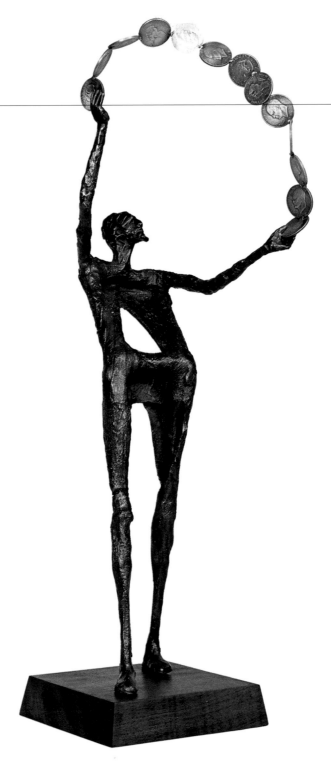

MONEY MATTERS
1992
Bronze and silver
28 x 10 in.
Private collection

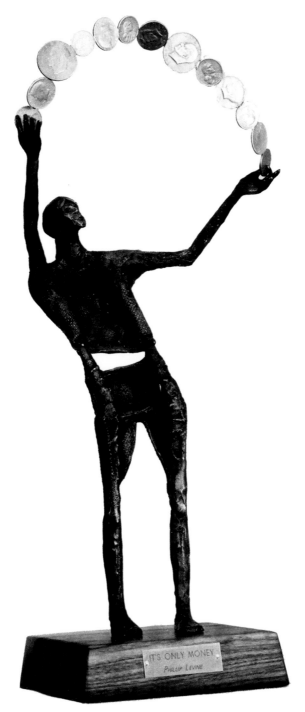

IT'S ONLY MONEY
2000
Bronze and silver
22.5 x 11 x 7 in.
Private collection

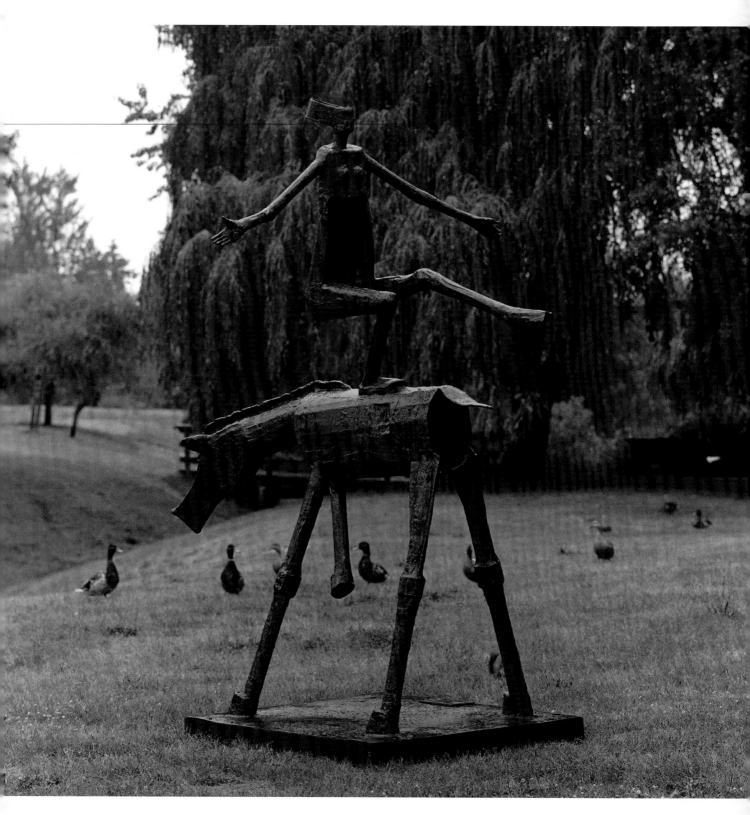

MYTH, MEMORY & IMAGE
1986
Bronze
90 x 72 x 54 in.
Kamiak High School, Mukilteo, WA
Purchased by the Washington State Arts Commission

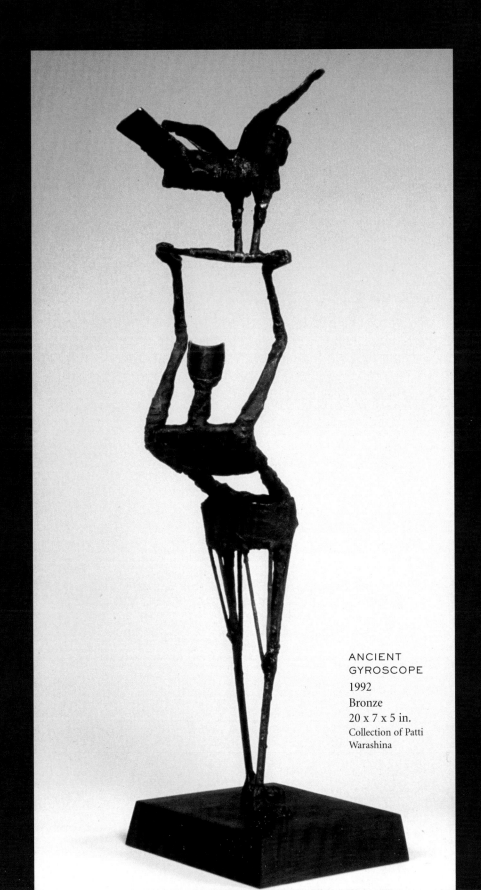

ANCIENT
GYROSCOPE
1992
Bronze
20 x 7 x 5 in.
Collection of Patti
Warashina

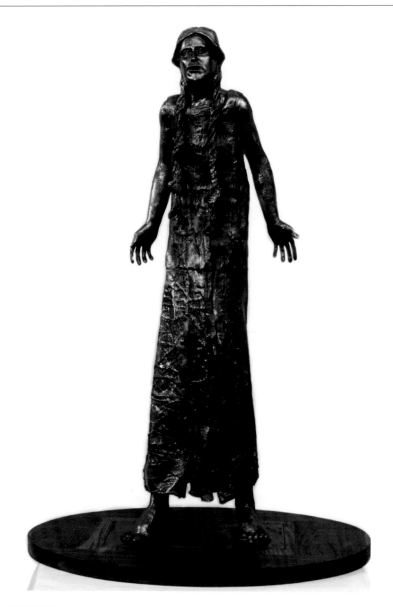

ELEKTRA
1978
Bronze
33 x 11 x 7 in.
Private collection

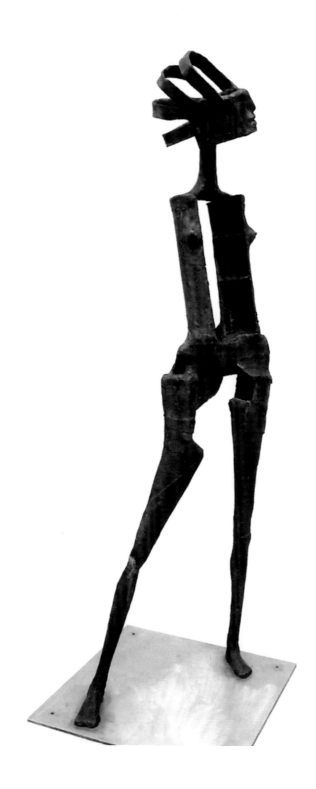

GODDESS
1996
Bronze
72 x 18 in.
Collection of the artist

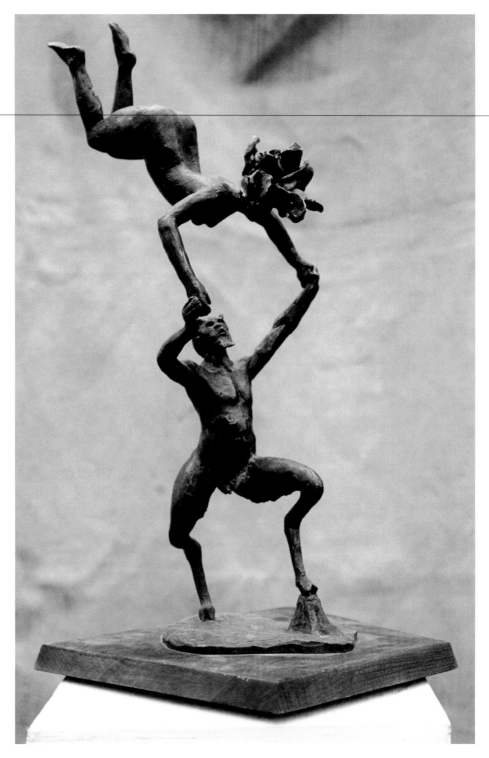

NYMPH AND SATYR
1966
Bronze
19.5 x 6 x 10 in.
Private collection

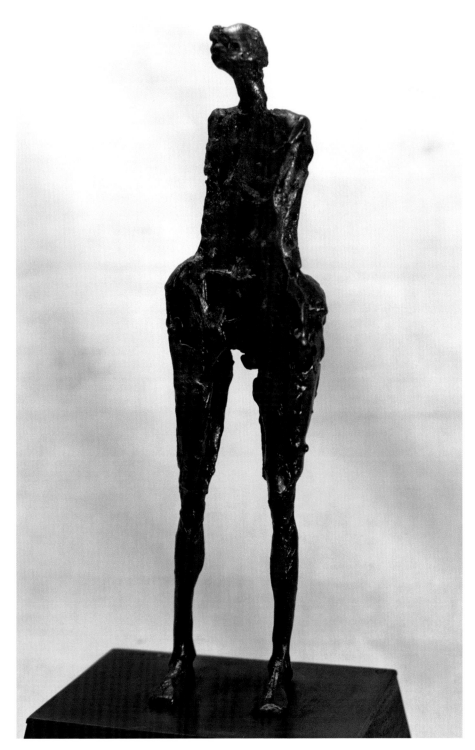

JETTON
1980
Bronze
11.5 x 3 in.
Collection of Lyle and Lois Silver

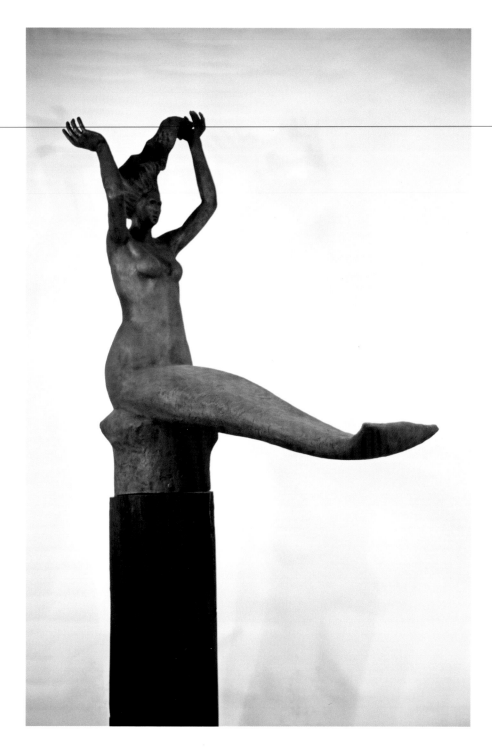

MERMAID
1986
Bronze and wood
76 x 17 x 36 in.
Oakland City Center, Oakland, CA
Commissioned by City of Oakland and
Bramalea Corporation

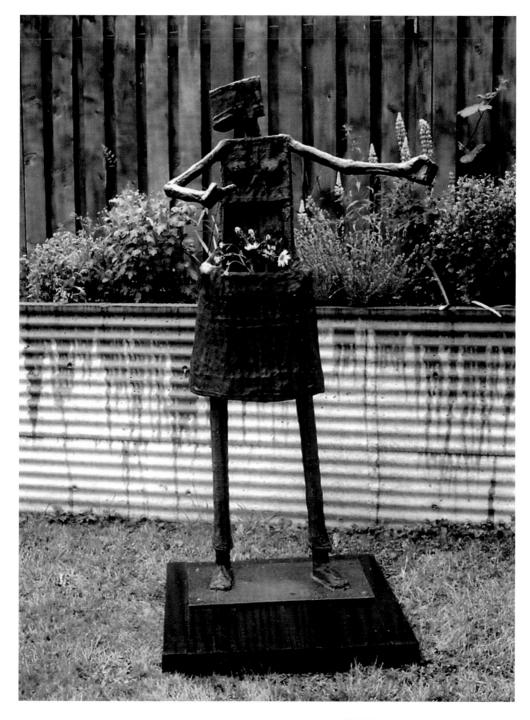

GAIA
1986
Bronze
76 x 39 x 24 in.
Collection of the artist

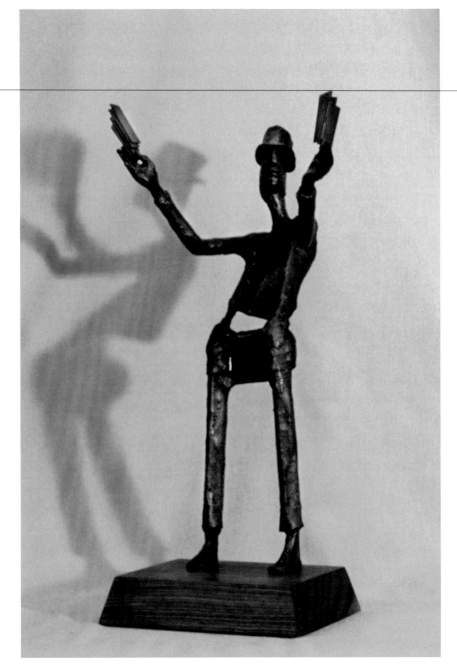

PICK A CARD
2001
Bronze
20 x 12 x 10 in.
Collection of the artist

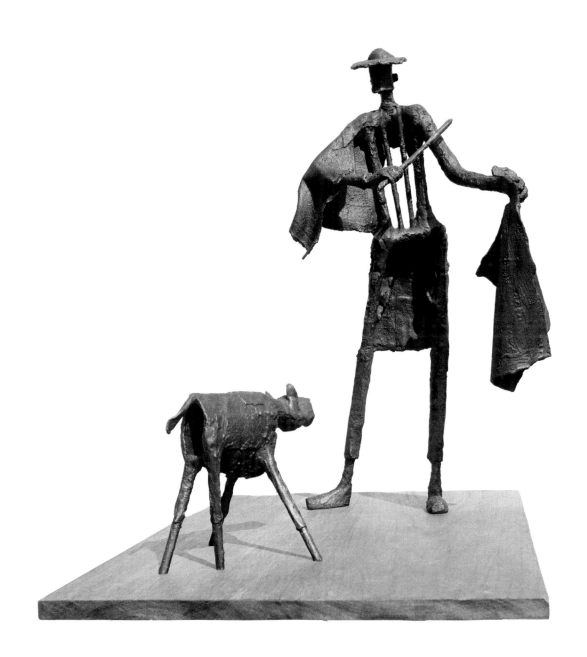

DON QUIXOTE'S BROTHER
1989
Bronze
25.25 x 20 x 30 in.
Omak Middle School, Omak, WA
Purchased by the Washington State Arts Commission

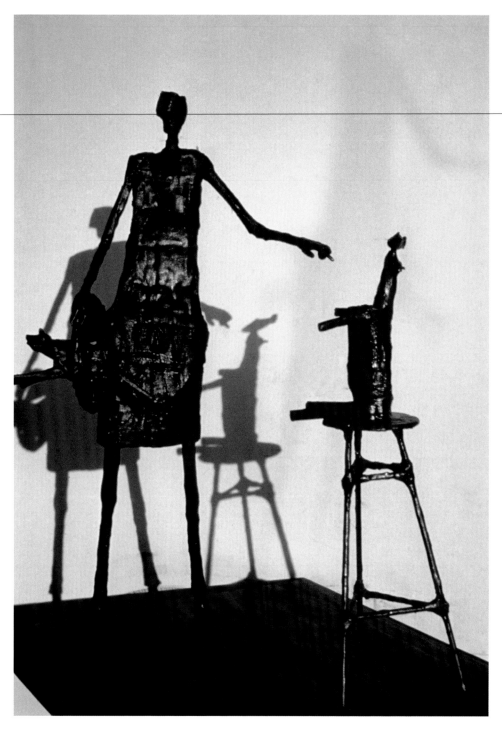

ANIMAL ACT
1982
Bronze
33 x 30 x 24 in.
Collection of the artist

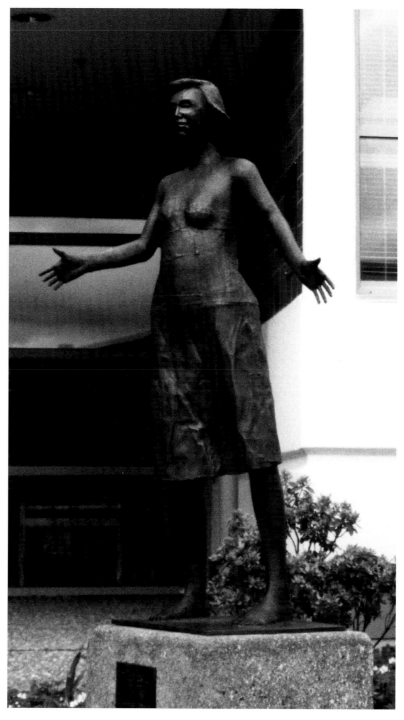

MOTHER JUSTICE
1993
Bronze
58 x 33 in.
Mountlake Terrace Police Station, Mountlake
Terrace, WA
Commissioned by the Mountlake Terrace Arts
Commission

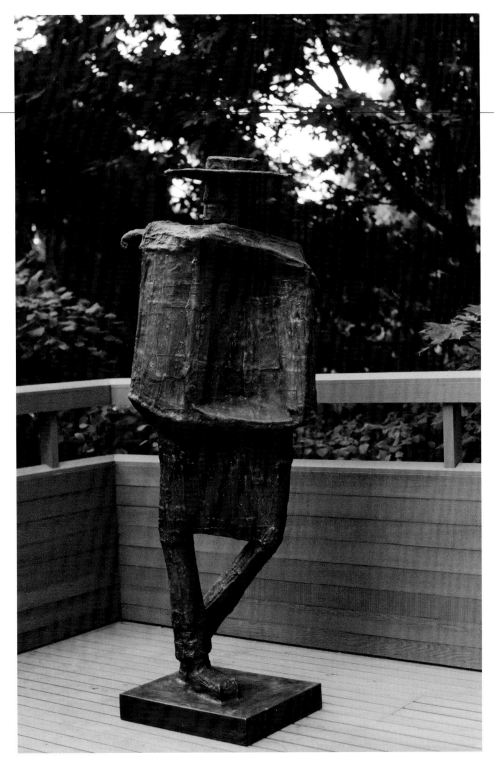

THE SHADOW
1982
Bronze
62 x 25 in.
Collection of Thomas and Susan Mulligan

The Seven Lucky Gods of Japan are gods that derive from Indian and Chinese gods of fortune. The "Shichifukujin" theme is a quite popular folk/religious theme in Japan. I was invited, with others, to submit a proposal for a sculpture incorporating the gods for the redevelopment of Akabane Station Plaza in Akabane, Tokyo. Yendo Design, the group in charge, was interested in discovering a fresh interpretation/abstraction of these figures. A representational and narrative direction was thought to be suitable. Given that each god represented many aspects, I submitted photos of two of the gods I had done along with my proposal. I finished second in this competition. The idea of the gods was so stimulating and intriguing in terms of the range of what they conveyed that I later decided to finish the group. They have not been shown and are in the collection of Judy and Aaron Levine.

FUKUROKUJU

Three gods in one: god of happiness, riches, and longevity. Short body, long head, which comprises more than half his height. Large, far-seeing eyes, puckered mouth, faint smile. Usually accompanied by tortoise, snake, stork, white deer, the four sacred supernatural creatures, symbolizing long life. Likes to play chess.

1999
Bronze
21 x 13 x 10 in.

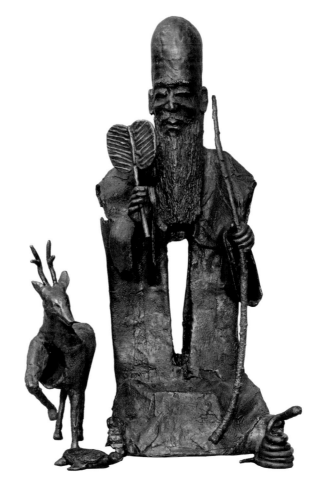

Guardian of Buddha and Buddhist virtues, mistakenly called god of war. One of the four kings of heaven. In India he was the god of fortune, treasure, and happiness; in Japan the god of dignity, defender against evil, and bringer of fortune. He bestows happiness and fortune-symbolic-faith, straightforwardness, duty, and honor. Also god of healing, patron of doctors, missionaries, soldiers, and priests.

1999
Bronze
24 x 15 x 5 in.

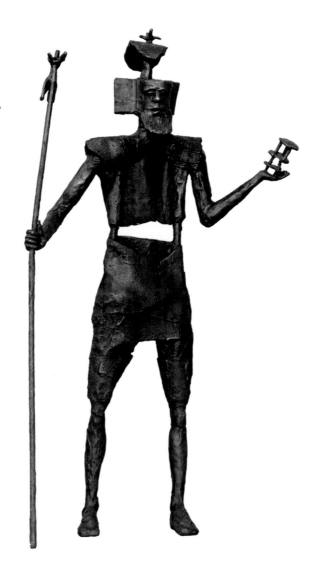

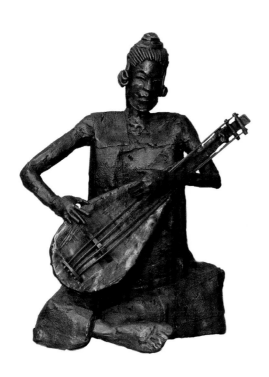

BENSAITEN

Or "Benten." Goddess of music, the arts, and eloquence and the only goddess of the seven. Carries an instrument, the biwa. In India goddess of fortune. Jealous goddess, indicated by white snakes often coiled around her. Patron of all the performing arts, writers, geishas, painters, businessmen, allied trades, sculptors, and gamblers.

1999
Bronze
13 x 11 x 8 in.

DAIKOKU

God of war and fortune. Possibly derived from Indian god of death. Carries golden mallet of wealth. Broad smiling face, short pointed beard, short-legged, plump. Patron of farmers, businessmen, allied trades. Demon chaser. God of five cereals.

1999
Bronze
18 x 10 x 7 in.

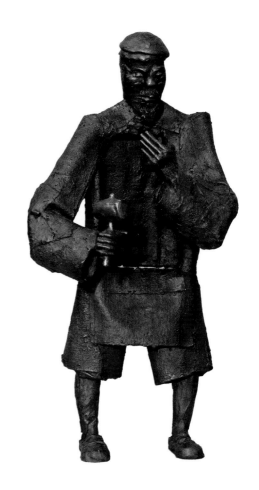

JUROJIN

Taoist god of wisdom. The scroll attached to his holy staff contains all the wisdom in the world. Heavy drinker and fond of female company. Although wise and good-natured, not highly thought-of in Japan. Was also known as the god of longevity.

1999
Bronze
23 x 8 x 6 in.

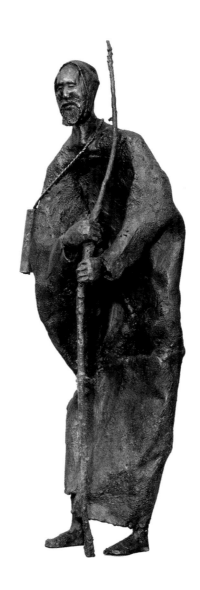

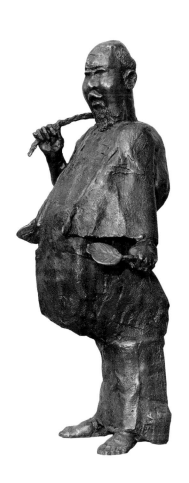

HOTEI

God of fortune, guardian of children, patron of fortune tellers, wits, and bartenders. God of popularity, magnanimity, he is a full, fat, smiling man with bristling whiskers. Inner wealth and largeness of soul. Narrow forehead, huge belly protrudes through robes, looks half naked.

1999
Bronze
20 x 9 x 8 in.

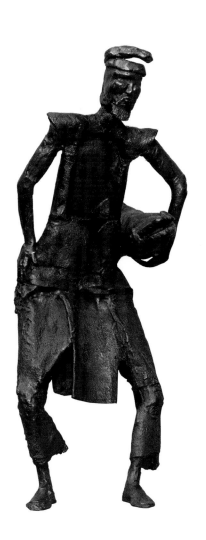

EBISU

God of candor, wealth, good fortune, fair dealing. Aristocratic dandy. Patron of doll theater and related arts. Fair dealing, patron of sailors, merchants, business executives, foreigners.

1999
Bronze
22 x 9 x 12 in.

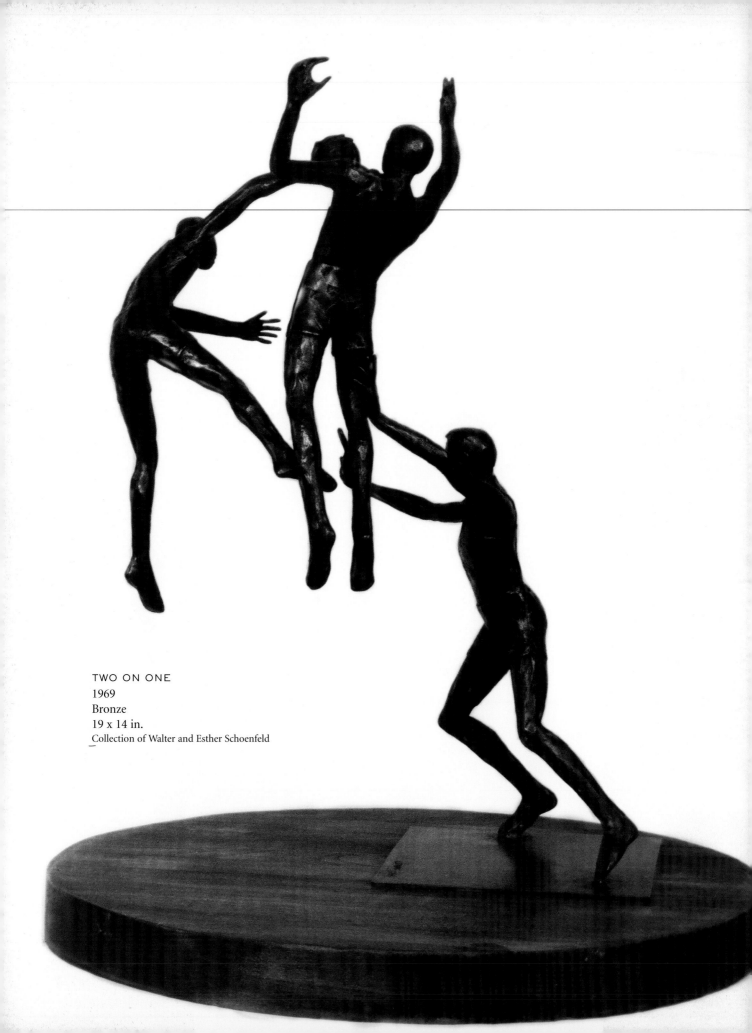

TWO ON ONE
1969
Bronze
19 x 14 in.
Collection of Walter and Esther Schoenfeld

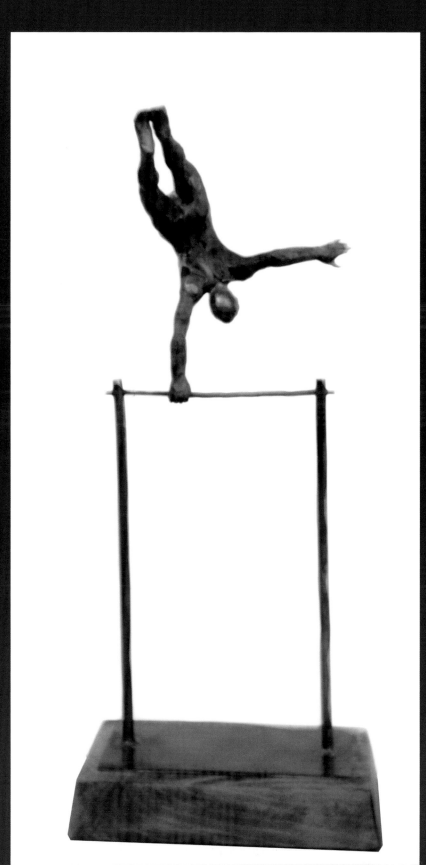

ACROBAT 2
1965
Bronze
20.5 x 5 in.
Private collection

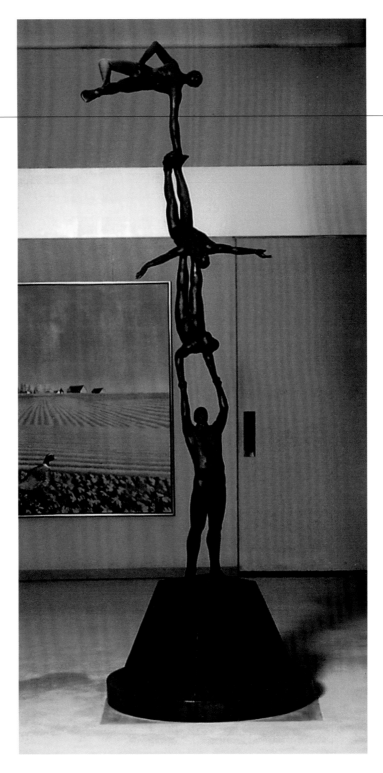

ACROBAT TOTEM
1969–74
Bronze
10 x 24 x 24 in.
Collection of Stoel Rives LLP

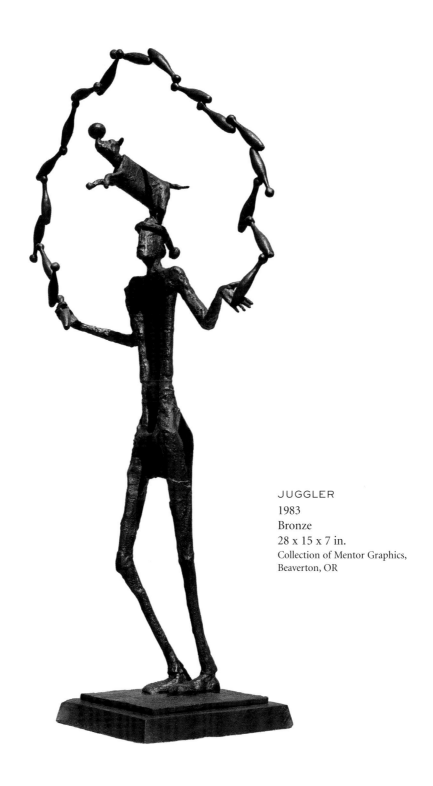

JUGGLER
1983
Bronze
28 x 15 x 7 in.
Collection of Mentor Graphics,
Beaverton, OR

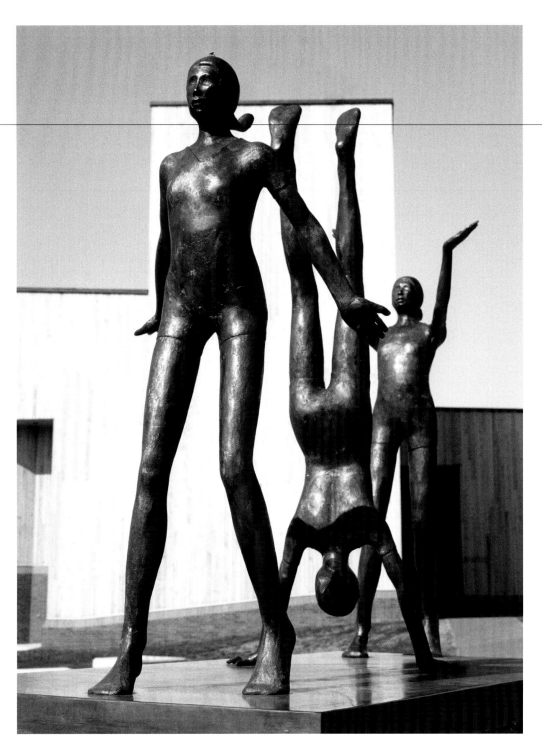

GYMNAST
1977
Bronze
36 x 52 x 24 in.
North Kitsap Middle School, Poulsbo, WA
Commissioned by the Washington State Arts
Commission

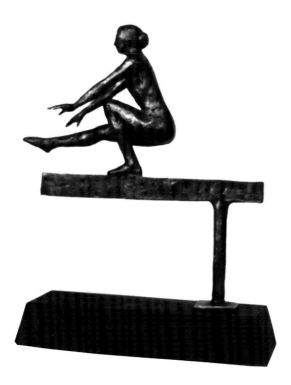

BALANCE BEAM
1972
Bronze
11.5 x 11 x 3 in.
Private collection

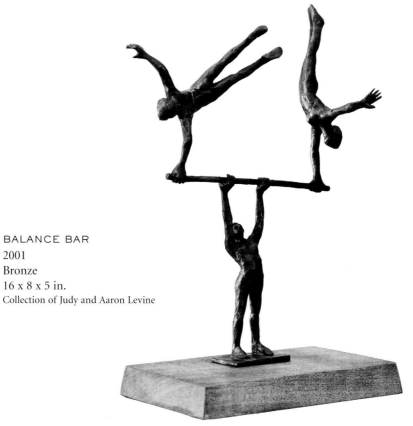

BALANCE BAR
2001
Bronze
16 x 8 x 5 in.
Collection of Judy and Aaron Levine

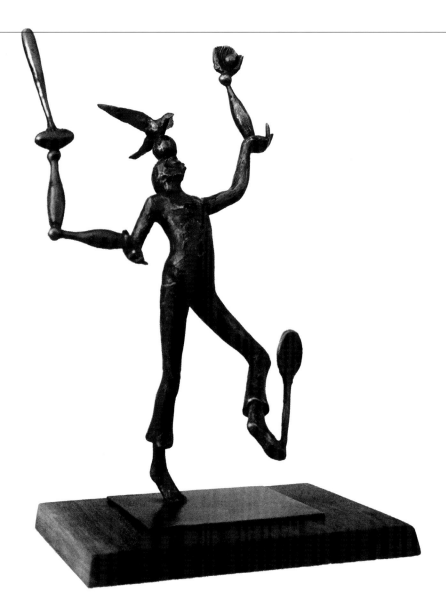

SPORTSMAN
1989
Bronze
13.5 x 9 in.
Collection of Steve Walker

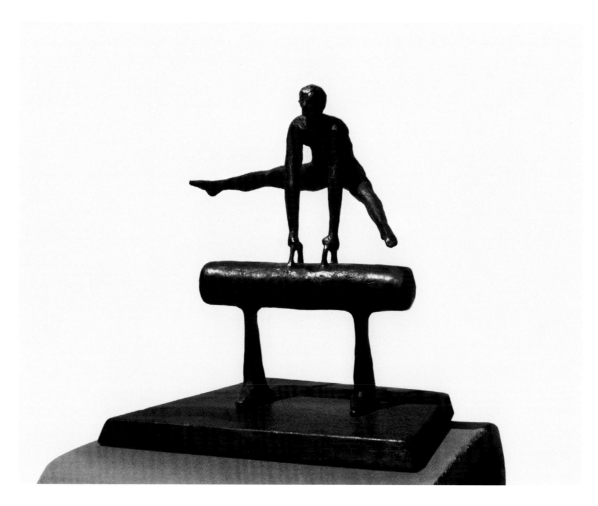

SIDE HORSE
1967
Bronze
10.5 x 7 x 6 in.
Private collection

CROUCHING WOMAN
Graphite with wash
22 x 16 in.

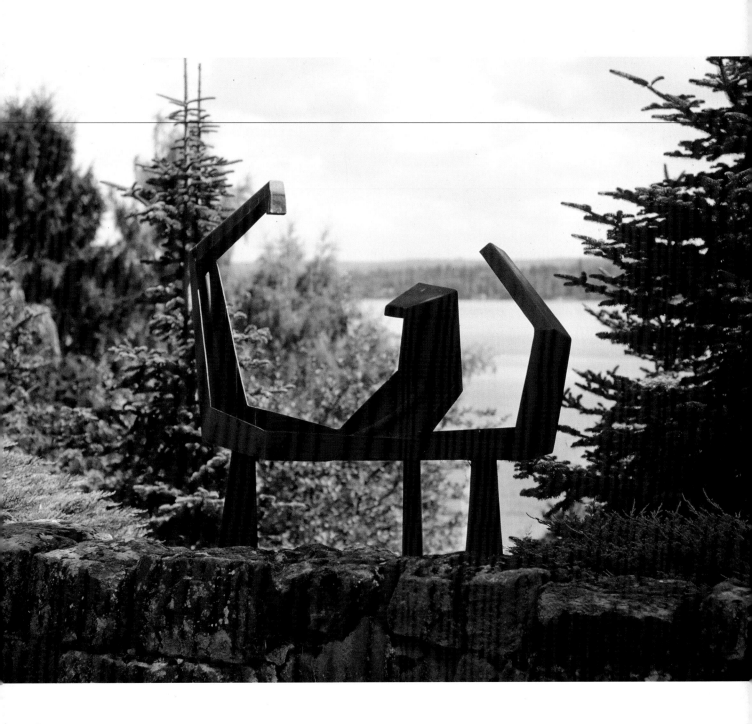

FOUNTAIN
1968
Bronze
48 x 72 x 36 in.
Commission by Patti and Sheffield Phelps

FOUNTAINS

FOUNTAIN
1977
Concrete
96 x 288 x 288 in.
Wenatchee High School, Wenatchee, WA
Commissioned by the Washington State Arts
Commission for the Art in Public Places Program.

I worked with the students on constructing the sculpture, and lived in Wenatchee during the weeks of construction.

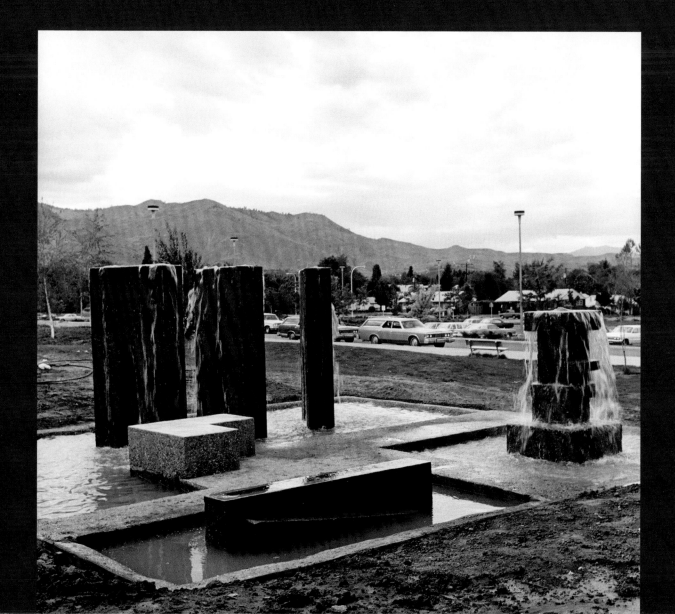

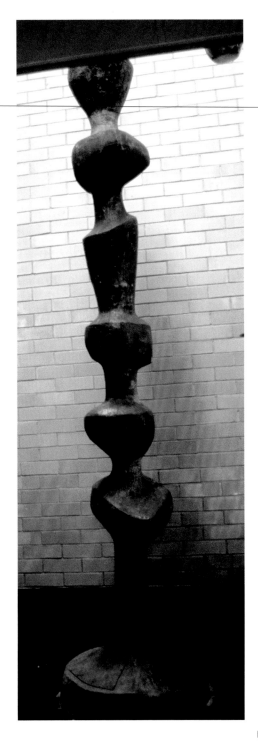

ENDLESS COLUMN
1973
Bronze
156 x 24 in.
Nord Building, Everett, WA
Commissioned through Dave Turner,
Architect

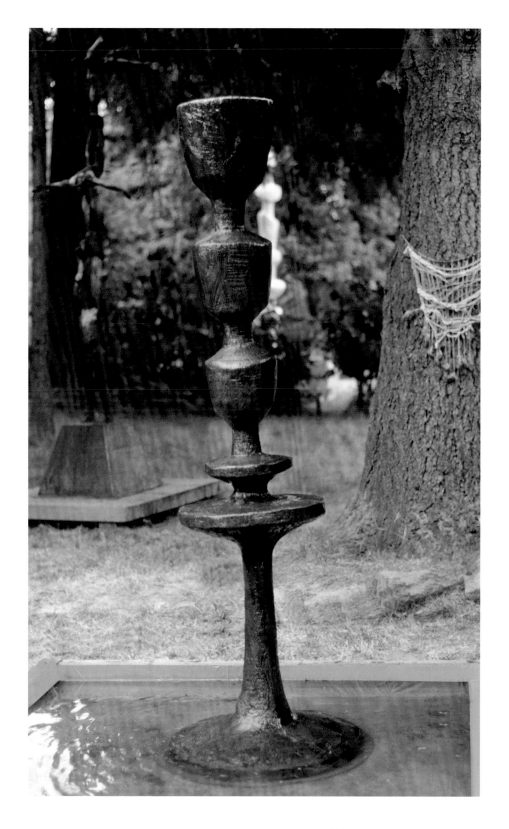

FOUNTAIN
1974
Bronze
84 x 30 x 30 in.
Collection of the artist

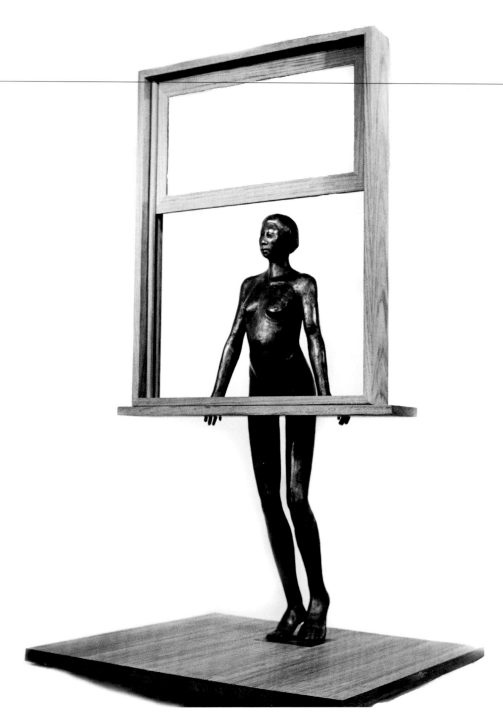

WOMAN AT THE WINDOW
1978
Bronze, wood, and glass
41.5 x 22 x 11 in.
Private collection

FIGURE/STRUCTURES

NO EXIT
1992
Bronze
11 x 13 x 9 in.
Collection of the artist

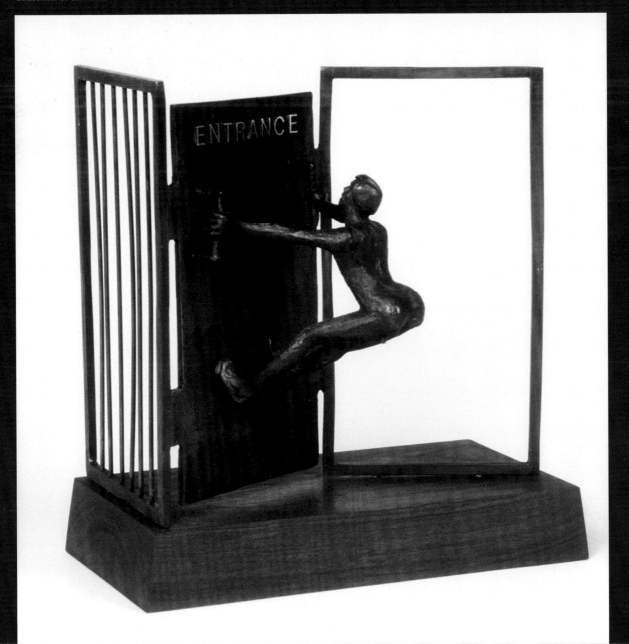

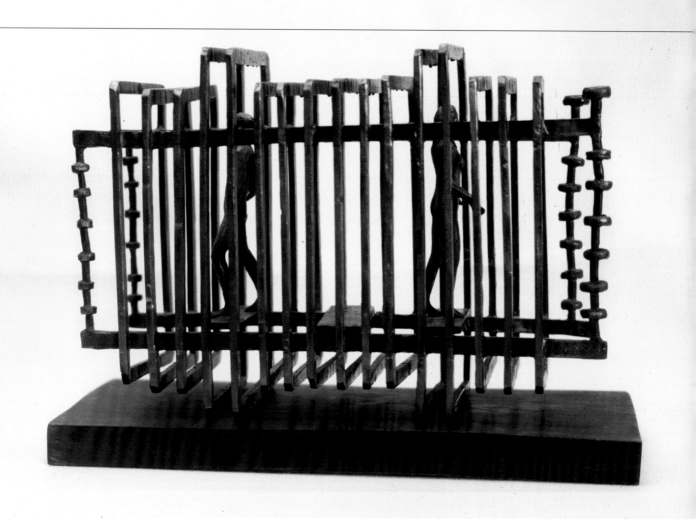

I WORRY ABOUT WORRYING
1972
Bronze
8.5 x 12 x 4 in.
Private collection

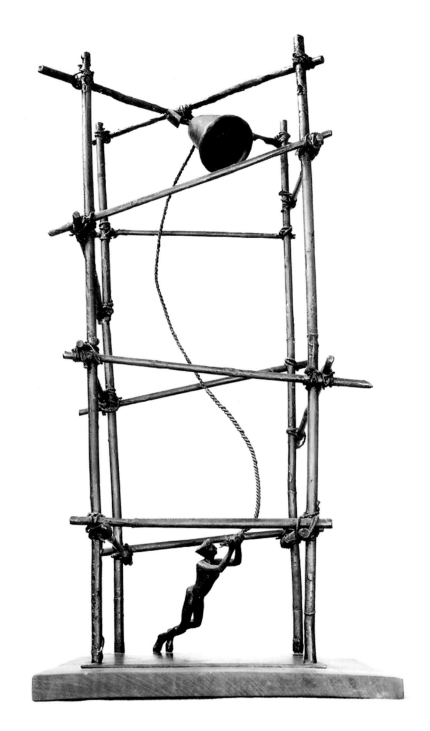

BELL TOWER 2
2000
Bronze
28.5 x 14 x 14 in.
Collection of the artist

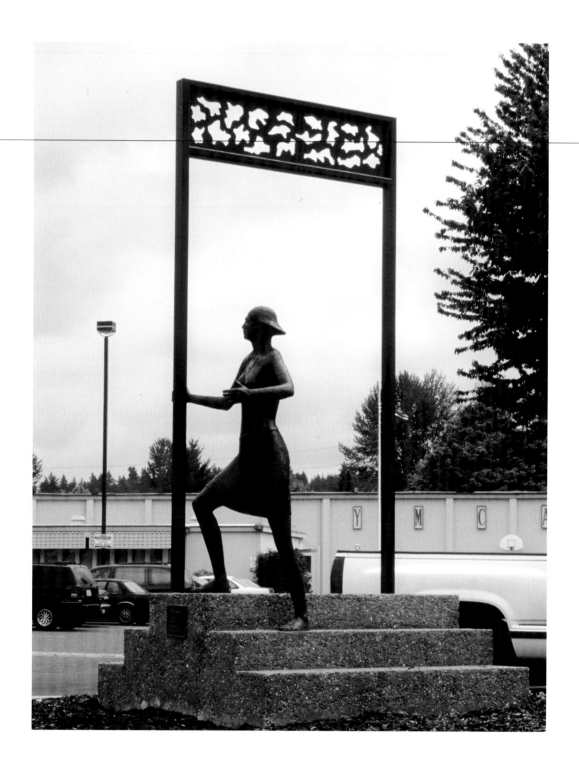

THRESHOLD
2001
Bronze, steel, and concrete
144 x 68 x 72 in.
Les Grove Park, Auburn, WA
Commissioned by the Auburn Arts Commission

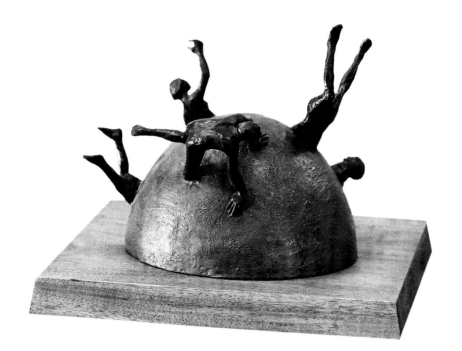

LEAVE IT ALONE
2001
Bronze
8.5 x 9 x 9 in.
Collection of the artist

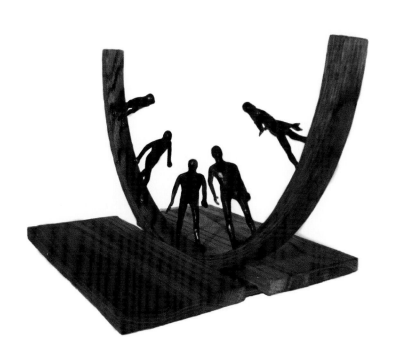

ROCKER FIGS
1974
Bronze and oak
11 x 18.25 x 12 in.
Collection of Stephanie and Josh Levine

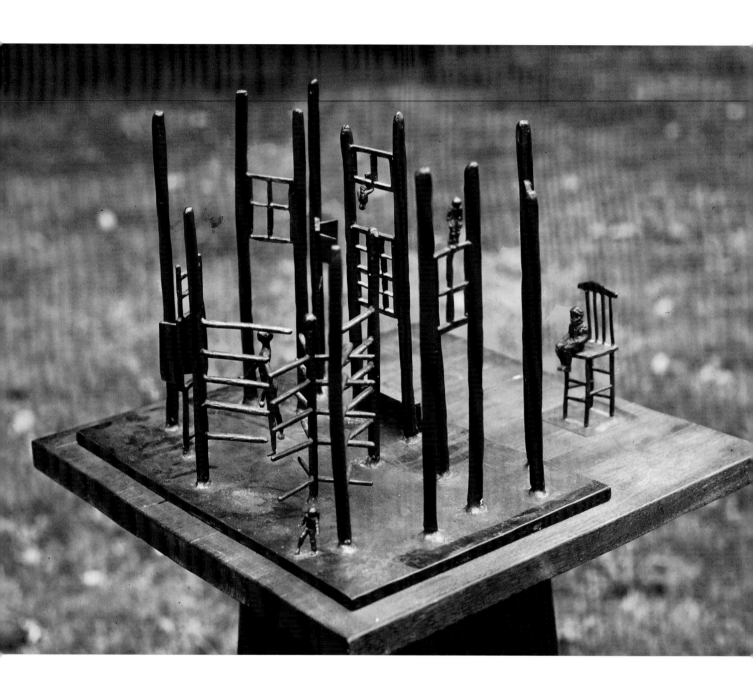

EXPONENTIAL FACTOR
1969
Bronze and glass
14 x 20 x 20 in.
Collection of the artist

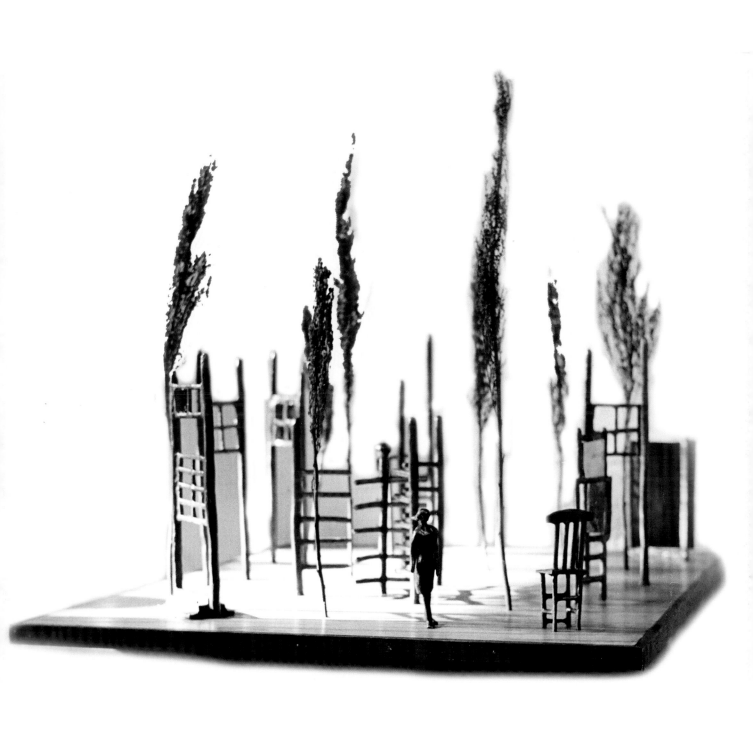

EXPONENTIAL FACTOR
VARIATIONS
1969
Bronze with branches
10 x 22 x 26 in.
Collection of the artist

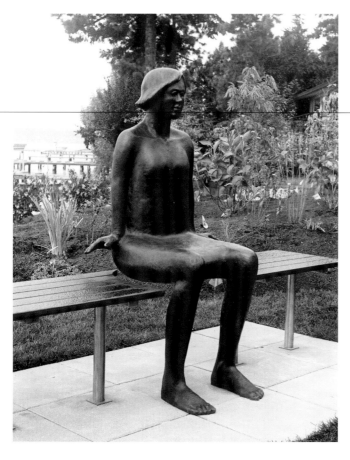

LA SIGNORA DEL LAGO
1998
Bronze, wood, and stainless steel
53 x 97 x 26 in.
Commissioned by Jane Dowdle and Max Morgan

ONE DAMN THING
1972
Bronze
8 x 10 x 4 in.
Private collection

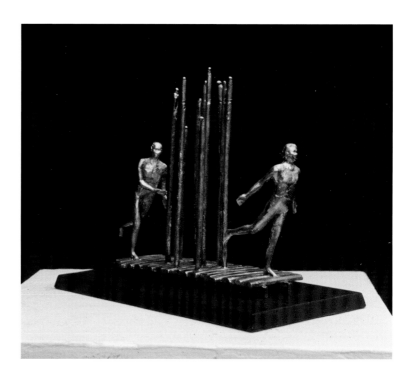

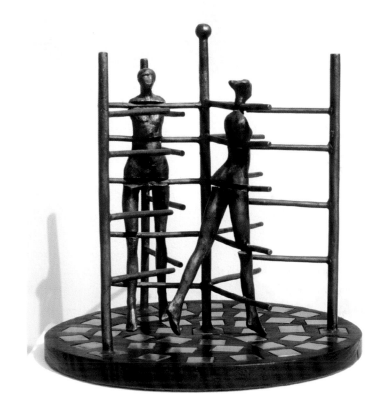

ENTER HERE, EXIT THERE
1976
Bronze
12.5 x 13.5 x 13.5 in.
Collection of Christine and Karl Anderson

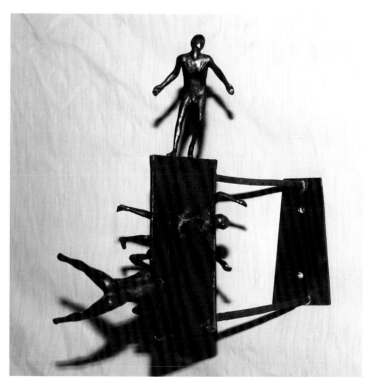

ACES, STRAIGHTS & FLUSHES
1971
Bronze
14 x 11 x 5.5 in.
Collection of Parks and Ginger Anderson

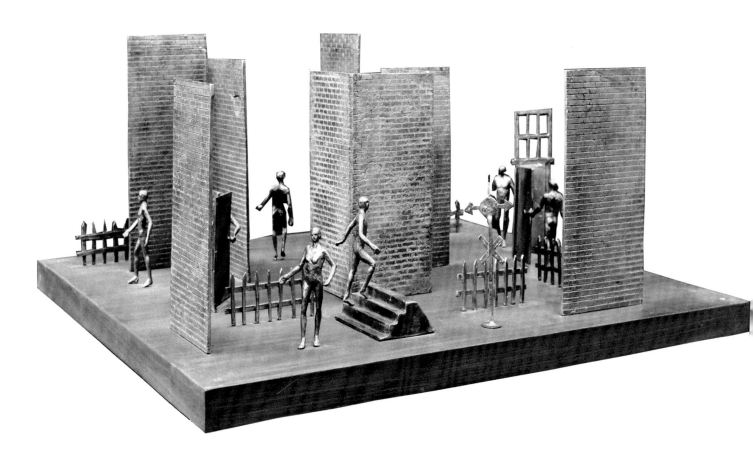

I LOVE YOU BUT IT'S
NOTHING PERSONAL
1991
Bronze
11.5 x 31.25 x 28 in.
Collection of the artist

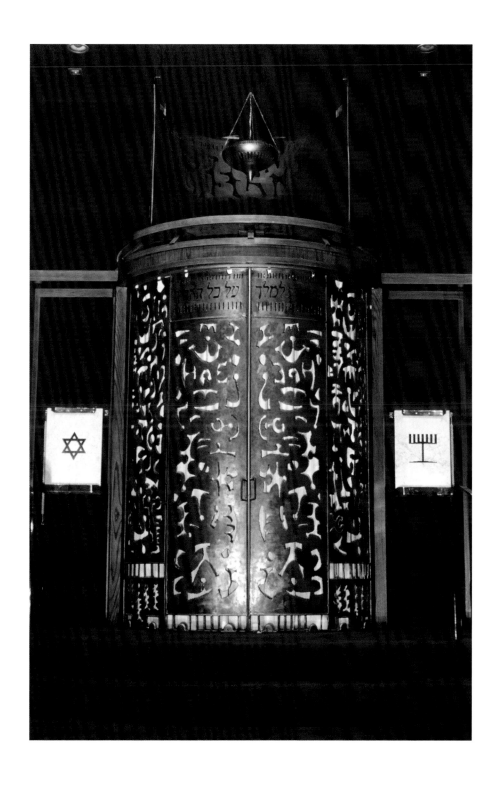

ARK DOORS
1972
Bronze
Four doors, each 96 x 26 in.
Eternal Light screen created later
Commissioned by Herzl-Ner Tamid Synagogue,
Mercer Island, WA

MOUNTAIN SPIRITS
1976
Cor-ten steel
96 x 201 in.
Jenkins Junior-Senior High School, Chewelah, WA
Commissioned by the Washington State Arts
Commission

SHURFRESH
1973
Bronze, mixed media
9 x 11 x 7 in.
Collection of the artist

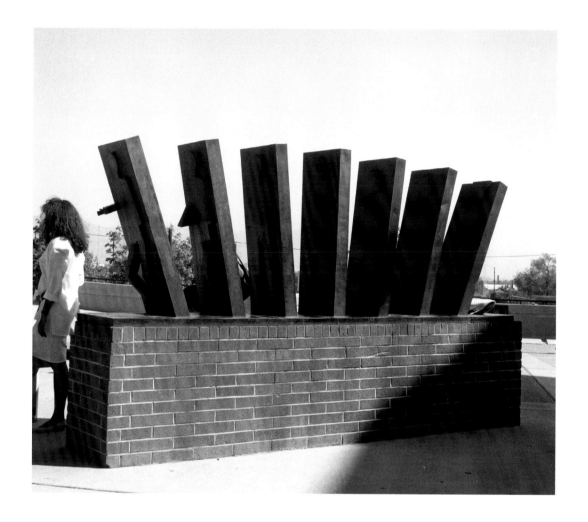

This piece shows the evolution of the figure with a recessed design in back and raised design in front.

MONOLITH
1977
Bronze
84 x 144 x 24 in.
Davis High School Yakima, WA
Commissioned by the Washington State Arts Commission.

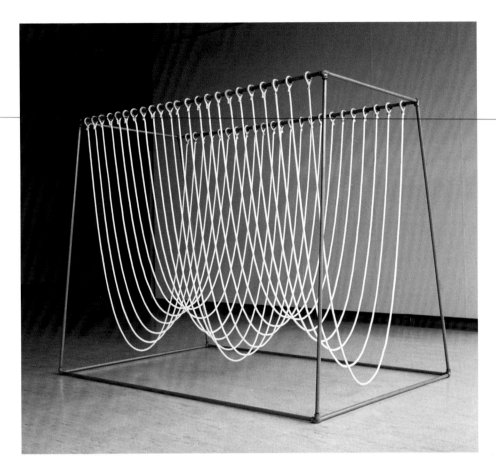

DOUBLE WAVE
1974
Steel and nylon
84 x 108 x 72 in.
Dismantled

HOMAGE TO HOKUSAI
1974
Steel and nylon
144 x 180 x 72 in.
Dismantled

THROUGH A GLASS DARKLY
1974
Steel, nylon, and glass
96 x 108 x 72 in.
Dismantled

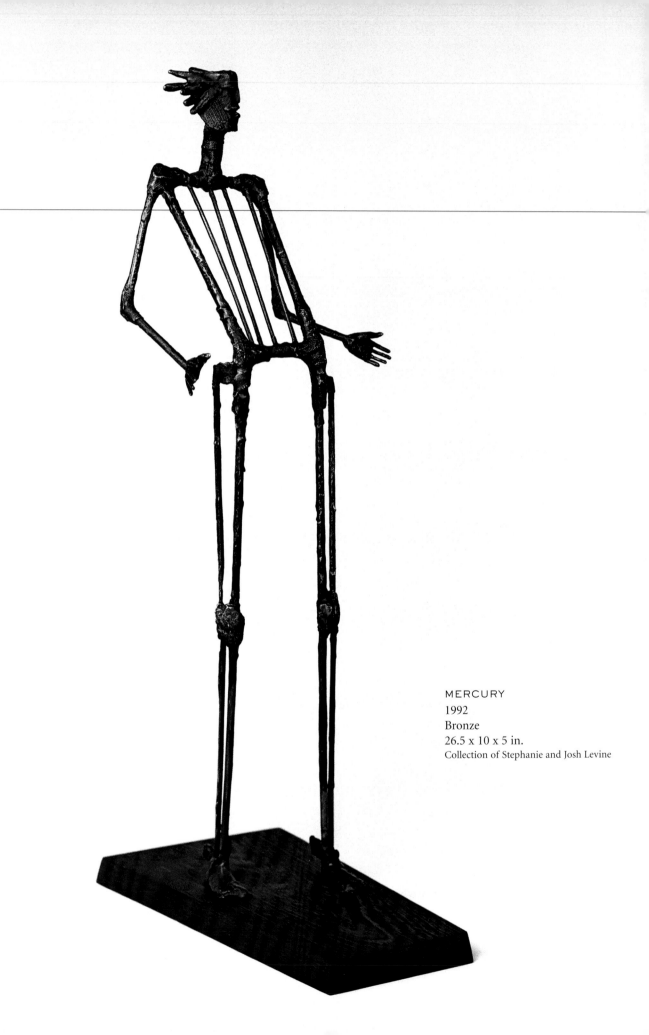

MERCURY
1992
Bronze
26.5 x 10 x 5 in.
Collection of Stephanie and Josh Levine

RÉSUMÉ

ONE PERSON EXHIBITIONS

2007	Insights Gallery, Anacortes, WA
2002	Clark's Fine Arts Gallery, Southampton, NY
	Color Graphics, Seattle, WA
2001	Clark's Fine Arts Gallery, Southampton, NY
	Color Graphics, Seattle
1997	Gallery at Madison Audio, Seattle
1996	Kirkland Library Sculpture Garden, Kirkland, WA
1993, 1994	Stonington Gallery, Seattle
1992	Janet Huston Gallery, La Conner, WA
1991	Upper Edge Gallery, Snowmass, CO
1990	Janet Huston Gallery, La Conner
1987	Wing Luke Asian Art Museum, Seattle
Victor Fischer Galleries, Oakland, CA	
1986	Tacoma Art Museum, Tacoma, WA
1976	Source Gallery, San Francisco, CA
1974	Foster White Gallery, Seattle
1971	Coos Bay Art Museum, Coos Bay, OR
Fountain Gallery, Portland, OR	
1969	State Capitol Museum, Olympia, WA
1968	Cascade Gallery, Seattle Center, Seattle
1967	Pacific Lutheran University, Tacoma
1966	Attica Gallery, Seattle
Panaca Gallery, Bellevue, WA	
1964, 1965	Panaca Gallery, Bellevue

GROUP EXHIBITIONS

2007–2008	Sisko Gallery, Seattle
Insights Gallery, Anacortes, WA	
2007	Redmond Sculpture Invitational, Redmond, WA
Harbor Steps Invitational, Seattle	
Insights Gallery, Anacortes	
West Edge Sculpture Invitational, Seattle	
2006	Harbor Steps Invitational, Seattle
Maryhill Museum Invitational, Goldendale, WA	
Insights Gallery, Anacortes	
La Conner Outdoor Sculpture Exhibition, La Conner	
West Edge Sculpture Invitational, Seattle	
2005	La Conner Outdoor Sculpture Exhibition, La Conner
Harbor Steps Invitational, Seattle	
West Edge Sculpture Invitational, Seattle	
2004	La Conner Outdoor Sculpture Exhibition, La Conner
2001	*Figure Northwest*, Port Angeles Fine Arts Center, Port Angeles, WA
Art and Cultural Center, Fallbrook, CA	
Museum of Northwest Art, La Conner	
1999	Abend Gallery, Denver, CO
Martin/Zambito Gallery, Seattle	
1998	Bellevue Sculpture Exhibition, Bellevue, WA
Simon Edwards Gallery, Yakima, WA	
1997	Sculpture Court Gallery, Southampton, NY
1996	New Leaf Gallery, Berkeley, CA
1993	Trojanowski Gallery, San Francisco
Vizual Art Galleria, Budapest, Hungary	
Galleria Charlotte Daneel, Amsterdam, The Netherlands	
1992	Galleria, Barcelona, Spain
A Garden for Sculpture, Bumbershoot Festival, Seattle |

1990	Azart Gallery, Seattle Victor Fischer Galleries, San Francisco City of Concord Art in Public Places, Concord, CA Sterling Company Ltd., La Jolla, CA	1976	Mayor's Invitational Exhibit, Salem, OR
1988	*Northwest Heritage,* Valley Museum of Northwest Art, La Conner	1975	Bellevue Art Museum, Bellevue University of Washington Summer Festival of the Arts, Seattle Governor's Invitational, State Capitol Museum, Olympia Ankrum Gallery, Los Angeles, CA Texas Fine Arts Association, Austin, TX
1986	*Fantasy on Wheels,* Bellevue Art Museum, Bellevue, WA		
1985	Tacoma Art Museum, Tacoma	1971	*Art for Public Places,* Henry Gallery, University of Washington, Seattle
1984	Oregon Invitational, Hult Center, Eugene, OR Third Biennial, Sculpture on the Green, University of Portland, Portland, OR	1969	*Five Seattle Sculptors,* State Capitol Museum, Olympia
1983	Source Gallery, San Francisco Contemporary Seattle Art, Bellevue Art Museum, Bellevue	1966	11th Annual Print and Drawing Exhibit, Oklahoma Art and Architecture Collaborative Exhibit, Seattle Art Museum, Seattle Cranbrook 5th Biennial, National Religious Art, Bloomfield Hills, MI
1981	*The Washington Year, A Contemporary View,* Henry Gallery, University of Washington, Seattle 33rd Annual, Cheney Cowles Museum, Spokane, WA	1963–1969	Northwest Annual, Seattle Art Museum
		1956	Roko Gallery, New York City, Painting
		1953	Denver Art Museum, Denver, CO

Wine Label
2008
Cotturi Winery and Feingold
Vineyards

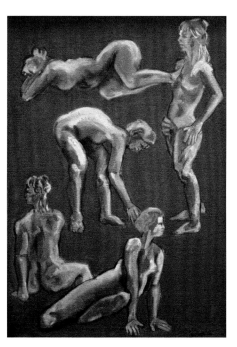

WISDOM OF THE BODY
2007
Book Cover for *Wisdom of the
Body,* by Judith Roche, Poet
Black Heron Press

COLLECTIONS

Voyager Middle School, Everett, WA

Peter Ogden Elementary School, Vancouver, WA

Embry Riddle Aeronautical University, Prescott, AZ

Omak Middle School, Omak, WA

Paccar Company, Bellevue, WA

First Hill Medical Building, Seattle, WA

Bramalea Pacific Corporation, Civic Center,
 Oakland, CA

Seattle Art Museum, Seattle

Rainier Club, Seattle

Mentor Graphics, Beaverton, OR

Frederick & Nelson, Southcenter, Tukwila, WA

Xiao Yang, Mayor of Chong Qing, Sichuan, China

Stoel Rives LLP, Seattle

City of Tukwila, Tukwila

Richards and Kinerk, Seattle

Safeco Corporation, Seattle

Teng Hsiao-Ping, Vice-Premier, China

Pacific Northwest Bell, Seattle

King Hassan, Morocco

University of Washington, Seattle

Burien Arts Association, Burien, WA

Anacortes Arts Association, Anacortes, WA

Eisaku Sato, Prime Minister of Japan

Private collections

COMMISSIONS

Bothell Regional Library, Bothell, WA, 2002, 1996

Les Grove Park, Auburn, WA, 2001

Temple Beth Am, Seattle, Josh Levine (lead), 2000

Lakeside School, Seattle, 1999

Morgan/Dowdle Residence, Kirkland, WA, 1998

Southwestern Oregon Community College, Coos Bay,
 OR, 1998

Kamiak High School, Mukilteo, WA, 1996

West Seattle Freeway Hillside, Seattle, 1996

Spokane Veteran's Arena, Spokane, WA, 1995

Mountlake Terrace Police Station, Mountlake Terrace,
 WA, 1992

Whitsell Residence, Portland, OR, 1991

Club Sport, Oakland, CA, 1990

Shell Oil Company, Martinez, CA, 1990

Mercer Island Arts Council, Mercer Island, WA, 1988

John Muir Hospital, Walnut Creek, CA, 1987

Koll North Creek Tech Center, Bothell, WA, 1985

Kline-Galland Home, Seattle, 1983

300 Elliott Bay Building, Seattle, 1982

Gene Coulon Memorial Park, Renton, WA, 1982

Duff Kennedy Residence, Seattle, 1981, 1972

Hibernia Bank, San Francisco, 1980

Beacon Hill Elementary School, Kelso, WA, 1980

Sammamish River Trail Park, Redmond, WA, 1979

Bellevue Athletic Club, Bellevue, WA, 1979

Burien Police Station and Courts, Burien, WA, 1978

Liberty Park, Poulsbo, WA, 1977

Wenatchee High School, Wenatchee, WA, 1977

Davis High School #2, Yakima, WA, 1977

North Kitsap Middle School, Poulsbo, WA, 1976

Medical Lake Middle School, Medical Lake, WA, 1976

Jenkins Junior-Senior High School, Chewelah, WA,
 1976

State of Washington East Capitol Campus, Olympia,
 WA, 1975

Highline Swimming Pool #2, Des Moines, WA, 1973

Nord Building, Everett, WA, 1972

Herzl-Ner Tamid Synagogue, Mercer Island, WA, 1972

Enumclaw Medical Clinic, Enumclaw, WA, 1970

Carco Theatre, Renton, 1969

Ner Tamid Synagogue, Bellevue, 1969

Herman Sarkowsky Residence, Bellevue, 1969

Tiffany Park Elementary School, Renton, 1968

Sheffield Phelps Residence, Seattle, 1965

Plaza 5 Restaurant, IBM Building, Seattle, 1964

Adelaide Elementary School, Federal Way, WA, 1962

Kim's Broiler, Seattle, 1962

BORN

Chicago, Illinois, March 1, 1931

EDUCATION

BA, Fine Arts, University of Colorado, 1953

New School for Social Research- New York City, 1955–58

MFA, Sculpture, University of Washington, 1961

TEACHING

University of Washington, Seattle, Teaching Assistant, 1959–61

 Extension Division, 1961–63

 Acting Instructor, 1981–62

Phoenix School of Ceramic Art, Seattle, 1962–63 (also Director)

Burnley School of Professional Art, Seattle, 1963–63

Fidalgo Allied Arts, La Conner, WA, Summer 1965–66

Pacific Lutheran University, Tacoma, WA, Summer 1967

Skagit Valley College, Mt. Vernon, WA, Summer 1971

Southwestern Oregon Community College, Coos Bay, OR, Summer 1971

Port Townsend Summer School, Fort Worden, Port Townsend, WA, Summer 1975

AWARDS

Washington State Governor's Arts Award, Cultural Enrichment, 1997

Burien Arts and Crafts, 10 awards, 3 First, 3 Second, 1 Purchase

Anacortes Arts and Crafts, 6 awards, 2 First, 2 Second, 1 Purchase

Edmonds Arts and Crafts, 4 awards, 4 First

Renton Arts and Crafts, 2 awards

Bellevue Arts and Crafts, 2 awards

Olympic Arts and Crafts, 1 award, First

Bainbridge Arts and Crafts, 1 award, First

Bumbershoot Arts and Crafts, 1 award

Mercer Island Arts and Crafts, 1 award, First

PROFESSIONAL ORGANIZATIONS

King County Arts Commissioner. Six years. Officer Alliance of Northwest Sculptors. Past President Northwest Sculptors Association. Past President Washington Chapter Artists Equity. Past Vice-President Puget Sound Group of Northwest Painters

BIBLIOGRAPHY

BOOKS

Ament, Dolores Tarzan. *Irridescent Light: The Emergence of Northwest Art*. Photographs by Mary Randlett. Seattle: University of Washington Press, 2002.

Cone, Molly, Howard Droker, and Jacqueline Williams. *Family of Strangers: Building a Jewish Community in Washington State*. Seattle: University of Washington Press, 2002. For the Washington State Jewish Historical Society.

Lundin, Norman. *The Perception of Appearance*. Seattle: University of Washington Press, 22002.

Petterson, Henry. *Creating Form in Clay*. New York: Reinhold Book Company, 1968.

Rupp, James. *Art in Seattle's Public Places*. Photographs by Mary Randlett. Seattle: University of Washington Press, 1992.

ARTICLES

"Art Judge Knows What He Likes and He Knows Art." *Record Chronicle*, July 1981.

"Artist Makes Bronze Breathe." *Seattle Post-Intelligencer*, April 1984.

"Artists' Work Full of Natures' Power." *Seattle Times*, February 1993.

"He's into Heavy Art." *View Northwest*, March 1975,

"Private Face of Public Art." *Seattle Times*, July 1997.

"Levine's Molten Magic." *Art Access*, 2000.

"Local Sculptor Molds Majesty." *Highline Times*, April 1985.

"Sculptor Wins Governor's Arts Award." *The News*, June 1997.

ACKNOWLEDGMENTS

In both the studio and the outer world, one is part of time, culture, heredity, family, and friendships. The studio, however, is where one may choose to show their confluence in both the process and resulting work.

My parents, children of Russian immigrants, were of a generation trying to adapt to a world different from their parents. What both generations prized and passed on was the love of knowledge (education) and the importance of relationships. My older sister, Sandy, showed by example how to be independent and at the same time be concerned with family and creativity.

My first art teachers were at the University of Colorado: Lynn Wolfe, a sculptor and painter, and Dorothy Eisenbach, a painter. From them I took in their passion for making art and sharing this passion with students.

After graduation, I attended a small art school in Denver. There I studied painting with Enrique Montenegro, who had taught Elmer Bischoff, Richard Diebenkorn, and other future Bay Area artists. Another teacher at this school was Leonard Schwartz, a sculptor who had been living in England for many years after receiving a Guggenheim Grant. I saw how "being an artist" could be a passionate way to live.

At the University of Washington, my teachers were Everett DuPen and Robert Sperry. George Tsutakawa also served on my graduate committee. Working with them strengthened my studio mentality as they were all professional artists and excellent teachers.

About 1962 The Northwest Institute of Sculpture was formed. Members from Oregon included Betty Feves, James Lee Hansen, Tom Hardy, Manuel Izquierdo, Joanne Peekama. From Vancouver, BC, Jack Harmon, and from Washington Gordon Anderson, Harold Balazs, Dudley Carter, Howard Duell, Everett DuPen, Jack Fletcher, Robert Flynn, John Geise, Archie Graber, James Hales, Marvin Herard, Ted Jonsson, Mary McDiarmid, Ebba Rapp, Elias Schultz, Chuck Smith, George Tsutakawa, Norman Warsinski, Val Welman, James Washington, Jr., and Alan Wright. This group was lively and supportive in gaining public recognition of sculpture. We were active in advancing "Art in Public Places" legislation as well.

I was appointed to the King County Arts Commission in May 1986, where I served until June 1991. During that time we worked for the broadening of the State-Local Hotel-Motel tax. That addition, enacted in 1989, then provided a solid funding for the commission. It was a diverse group of people including Marita Dingus, Karen Guzak, Liz Huddle, Jesse Jamarillo, Larry Metcalf, Rick Simonson, Ann Spiers, and Susan Trapnell.

In 1985 I started a seminar group, which continues to meet monthly and has served as a gathering place to enlarge and enrich our world of ideas. Our topics have been far ranging in scope, including art, dance, physics, language, and poetry. The group has seen changes in participants over the years; here are some of them: Jerry Anderson, Kurt Beattie, Jim Coffin, Ted D'Arms, Eve Green, Malinda Holman, Lezlie Jane, Tom Jay, Ray

Jensen, Barnett Kalikow, Don Kartiganer, Susan Leslie, Aaron Levine, Norman Lundin, Dave Poleski, Judith Roche, Rick Simonson, and Llory Wilson. For many years the creative energies of R. Allen Jensen have shown me how varied are the approaches to art. Jim Coffin, in many ways a friend, a light, a spirit, was with me for much of this journey.

With special thanks to Norman Lundin for his Preface. Norman is professor emeritus of art at the University of Washington. His art has been exhibited at the Museum of Modern Art in New York, San Francisco Museum of Art, Whitney Museum of Art, the Art Institute of Chicago, the Frye Museum, and the Seattle Art Museum. As an artist and an academic, he is well-versed in the language of drawing and follows its allure in the process of artistic creation.

Also with special thanks to Tom Jay for his Foreword. Tom is a published poet/essayist and sculptor who has created many public and private sculpture commis-sions in the Northwest. He owned and operated Riverdog Fine Arts Foundry, the first such arts foundry in the Northwest, from 1996 to 1994, and has been active in the Northwest arts scene since receiving his MFA from the University of Washington in 1966.

Our sons, Josh and Aaron, artists themselves, have given me more than I have given them. I not only learned from them directly, but in seeing what they have accomplished with their art. The visions of our son Jacob have been part of the sources of my work. All three sons were actively involved in studio processes and the installations of completed works. Working with them always made me feel safe. My wife Rachael has been a steadfast rock. Her range of vision, interests, and regard of my work has sustained my life. We all have had mentors who we did not know as such when they were mentoring. Those we keep in our minds and hearts.

ISBN 978-0-295-98916-7

Distributed by University of Washington Press
P.O. Box 50096, Seattle, WA 98145 USA
www.washington.edu/uwpress

Museum of Northwest Art
P.O. Box 969
La Conner, Washington 98257
www.museumofnwart.org

Frontispiece: Phillip Levine, *Self Portrait*, 2007, oil on canvas, 9 x 12 inches.

PHOTO CREDITS

WILLIAM ENG: *Woman Dancing*, p. 27

VERN GREEN: *Prophets*, p. 41; *Swinger*, p. 60; *Rising Figure*, p. 62; *Acrobat*, p. 125

SCOTTY SAPIRO: *Walking on Logs (Hillside)*, p. 92

JOHN SISKO: *Board Walkers*, p. 91

JAMES SOBOTA: *Singer*, p. 26; *Conquistador*, p. 41; *Chicken*, p. 74; *Night Wing*, p. 91; *Love*, p. 102; *Nymph & Satyr*, p. 110;
Side Horse, p. 131

ERIK STUHAUG: *Cat's Cradle*, p. 28; *Playing the Fool*, p. 43; *James Coffin as Vasco Da Gama Discovering the New World*, p. 44;
Quest, p. 94; *Money Matters*, p. 104; *When Once We Worship*, p. 67; *Mercury*, p. 152

This book would not have been possible without the generous support of the following:

The Anne Gerber Estate
Phyllis Hatfield, for her excellent editing and support
Anne Gould Hauberg
Louise Hoeschen-Goldberg
King County 4Culture Grant